TOI ORA

Australia and
NEW ZEALAND

January 2011.

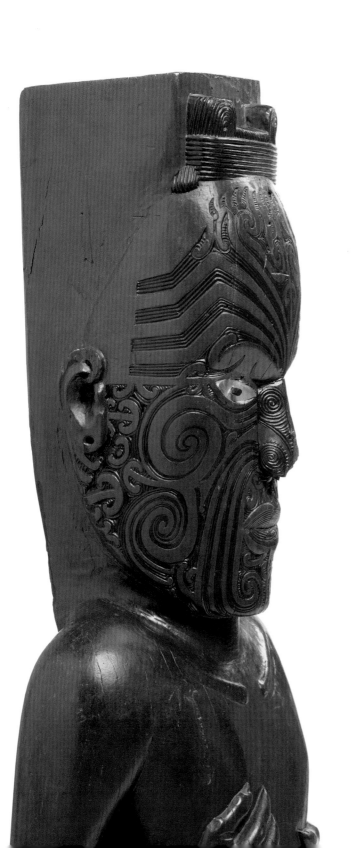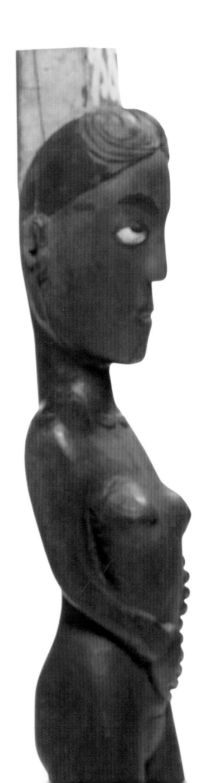

TOI ORA

ANCESTRAL MĀORI TREASURES

Edited by Arapata Hakiwai and Huhana Smith

TE PAPA

PRESS

First published in New Zealand in 2008 by
Te Papa Press, P O Box 467, Wellington, New Zealand

TE PAPA® is the trademark of the Museum of New Zealand Te Papa Tongarewa
Te Papa Press is an imprint of the Museum of New Zealand Te Papa Tongarewa

Toi ora : ancestral Māori treasures / Huhana Smith and Arapata Hakiwai, editors.
Includes index.
ISBN 978-1-877385-34-6
1. Art, Maori. 2. Art objects, Maori. 3. Maori (New Zealand people) — Antiquities.
4. [1. Mahi toi. reo 2. Tikanga tuku iho. reo] I. Smith, Huhana. II.
Hakiwai, A. T. (Arapata Tamati) 704.0399442—dc 22

Cover and template design by Walter Moala
Layout by Soda Design
Photography by Mike O'Neill
Digital imaging by Jeremy Glyde
Printed by Everbest Printing Co., China

Contents

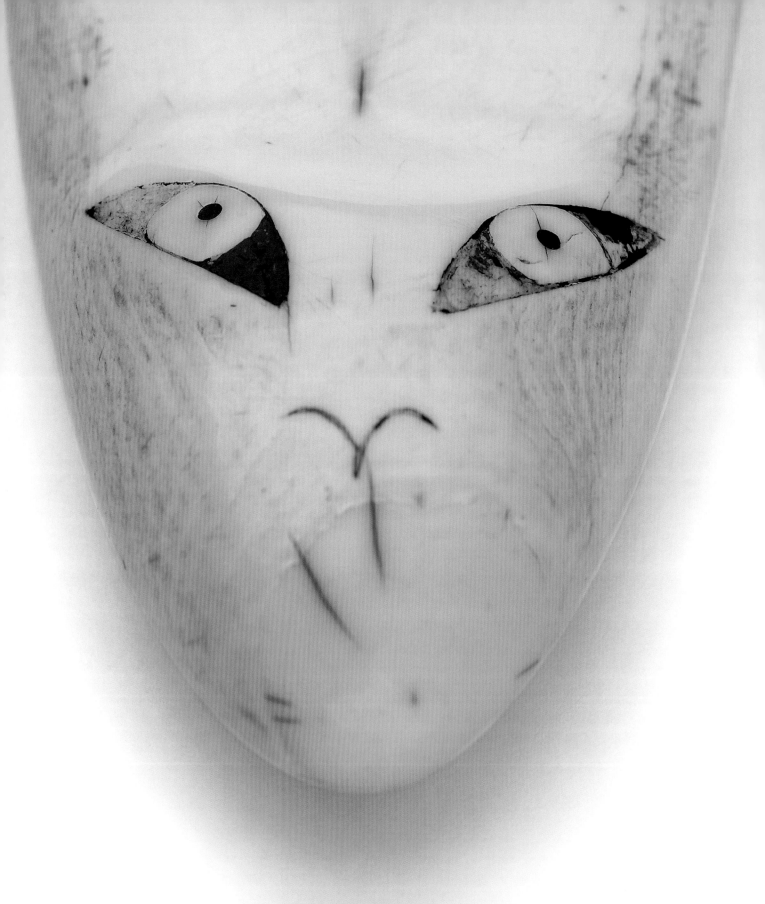

Preface

When Pacific knowledge, skills and technologies were applied in a new environment, a culture developed that was specific to the islands that make up Aotearoa New Zealand. The personal and communal taonga Māori (treasures) that exist today, whether in tribal ownership or in museums, remain highly valued.

The Museum of New Zealand Te Papa Tongarewa is a kaitiaki or guardian for an extensive collection of close to thirty-five thousand taonga Māori, including taonga from Moriori of Rēkohu, Chatham Islands. These taonga represent a thousand years of mātauranga or knowledge of skilled experts.

The taonga in *Toi Ora* form part of this collection. They range from intricately carved waka (canoes) and wharenui (meeting houses) through to musical instruments, fish-hooks and the extraordinarily beautiful woven cloaks. Some of these taonga are symbols of communal identity, some are objects of daily use, and others are ceremonial or seen only in some contexts. Importantly, they show that objects made by Māori expressed – through their visual language and purpose – the culture's beliefs about the world.

Central to the Māori concept of time is that history is not linear and fixed. The past exists as part of the present and the future. Taonga, in this view, are living treasures that represent practices that continue today.

Also underpinning many Māori concepts is the notion of growth, and this too is seen in the view of time. Scholar and writer Sidney (Hirini) Moko Mead designed a time sequence centred on the metaphor of seeds developing into fruit. This sequence has been refined by recent research, and has been used to show the likely dates for the taonga in this book. The first period, Ngā Kākano (The Seeds), refers to the era of establishing the human settlement of Aotearoa. The most recent period, Te Huringa (The Turning), refers to a change in development, when Māori encountered European culture.

Period	Dates (all Common Era)
Ngā Kākano (The Seeds)	1100–1300
Te Tipunga (The Growth)	1300–1500
Te Puāwaitanga (The Blossoming)	1500–1800
Te Huringa (The Turning)	1800–present
Te Huringa I	1800–1900
Te Huringa II	1900–1960
Te Huringa III	1960–present

The taonga in *Toi Ora* date from the Ngā Kākano period to Te Huringa I. They include communal taonga – waka, pātaka (storehouses) and wharenui – which express overarching statements of tribal identity. Personal taonga – objects of adornment, personal items of significance and tā moko (the marking of skin) – provide tribal connections, individual stories and expressions of belief. Lastly there are the taonga of daily living – fishing, defence and weaponry, and woven garments and treasures.

This book came about through a cultural exchange with Japan. Over five years, two exhibitions were developed. *Splendours of Japan: Treasures from the Tokyo National Museum* was shown at Te Papa in 2006, and the highly popular exhibition *Mauri Ora: Māori Treasures from the Museum of New Zealand Te Papa Tongarewa* was exhibited in Japan in 2007. The parameters of this book reflect those of the exhibition *Mauri Ora*, which was developed to draw out links with Japanese material culture. This explains why certain taonga are included but not others. For instance, *Toi Ora* features fishing tools but none for gardening or other types of food-gathering; the buildings discussed and illustrated are the wharenui and pātaka, rather than other major structures such as a chief's dwelling or a waharoa (entrance way).

Toi Ora is a collaborative project and Te Papa takes this opportunity to acknowledge editors Arapata Hakiwai and Huhana Smith, leading scholar Janet Davidson, and curators Matiu Baker and Awhina Tamarapa for their significant contributions to researching and writing this book.

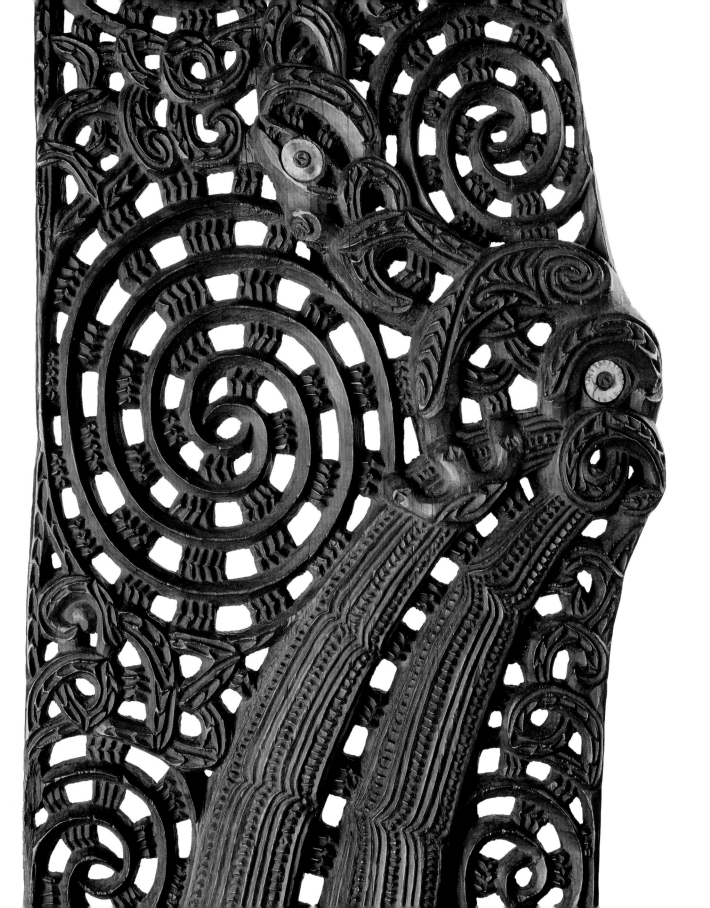

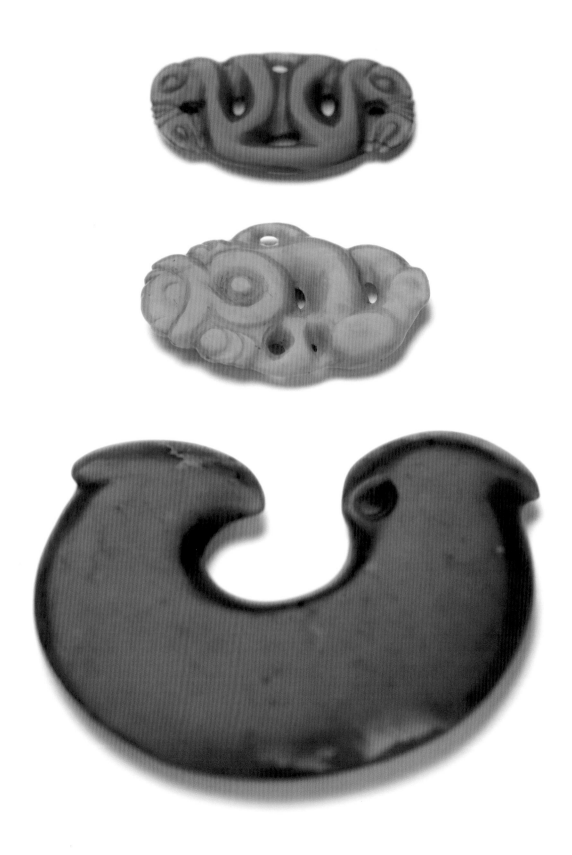

Māori

A living culture

Toi Ora is a glimpse into the treasure house that is Te Papa Tongarewa the Museum of New Zealand. As New Zealand's national museum, Te Papa is established on the basis of the partnership between tangata whenua – Māori, the indigenous people – and tangata tiriti, the people living in this country by right of the Treaty of Waitangi, the founding document of the nation, signed by representatives of the iwi (tribes) and the British Crown in 1840.

This book offers a view of mana taonga – the objects and relationships that are central to Te Papa's commitment to a bicultural principle. It showcases the treasures of a rich cultural and material heritage. For Māori, such taonga are more than objects. They have a mauri (life force) that transcends time, connecting past generations to those of the present and future. These taonga embody Māori cultural values, knowledge, histories and stories. Some represent ancestors, while others are named in remembrance of important historical events or occasions. Many evoke a powerful sense of the spiritual world in which they originated. They carry the mana (prestige) of those who made them, and of the people for whom they were made.

Te Papa recognises whakapapa (genealogical) connections and relationships with iwi, hapū (sub-tribes) and whānau (extended families). The underlying principle of mana taonga acknowledges the spiritual and cultural connections of taonga with their people through the whakapapa of the creator of the taonga, the ancestors after whom the taonga is named, and the whānau, hapū or iwi to whom the taonga belongs.

But mana taonga also highlights continuity. For Māori, the past is located in front (i mua) of the person; the future lies behind (i muri). Drawing on the customary knowledge represented by these taonga, Māori move towards the future with their eyes on the past, which informs their lives in the present. The taonga of this book, then, represent living culture, knowledge and practices. And it is hoped that people of other cultures and from other places will find their own connections with the remarkable objects shown here.

A place in the Pacific

He ao, he ao tea, he ao tea roa!
A cloud, a white cloud, a long white cloud!

These were the words of Kuramarotini, wife of the great navigator Kupe, on sighting New Zealand. 'He ao tea roa' gave rise to the best-known Māori name for this land – Aotearoa. Kupe is said to have been the first voyager to arrive with his people from Hawaiki, the name Māori give to their original home. His story is one of many Māori origin stories passed down from generation to generation.

The human colonisation of the Pacific region began more than 40,000 years ago, when people from Asia first reached Papua New Guinea and Australia. Technological advances in Asia and the development of large ocean-going vessels enabled a wave of migrants to move eastwards into the Pacific about 3500 years ago, settling islands as they went. The voyagers crossed the vast Pacific in large waka hourua (double-hulled sailing vessels), using their knowledge of the natural world and sophisticated navigational techniques to guide them. They made pottery, grew plant foods such as taro and bananas, and kept pigs, dogs and chickens. By 2900 years ago, some had reached Samoa and Tonga, where the art of pottery gradually declined and was eventually forgotten. Over the next 2000 years skilled navigators discovered and settled the islands of a huge triangular area bounded by Hawai'i in the north and Rapanui (Easter Island) in the east. Aotearoa New Zealand was the last major land mass they reached about 800 years ago.

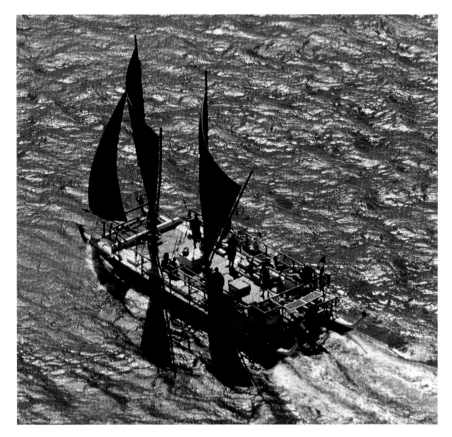

Te Aurere, a modern waka hourua, which has undertaken voyages of rediscovery throughout the Pacific, retracing routes taken 1000 years ago.

Te Taitokerau Tarai Waka Inc.

Māori oral histories tell of ancestors voyaging to Aotearoa in great waka. Studies in archaeology, genetics and linguistics are now filling in the details of these histories. The waka of the migration were quite different from those made later in the new country. In recent years, Māori and Pacific Islanders have built new versions of the ancient voyaging craft and sailed them successfully over long distances across the Pacific.

The ancestors of Māori arrived in a land with a mountainous interior that stretched over latitudes. They were used to a tropical climate, but found one here that ranged from sub-tropical in the north to cool temperate in the south, with alpine conditions in the mountains. The taonga in this book show how innovative Māori were in their adaptations to the new environment.

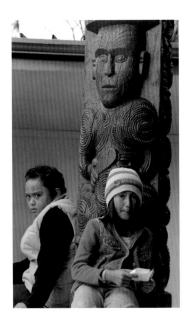

Children on Kōkōhinau Marae, Te Teko, during Ngāti Awa Treaty Settlement proceedings, April 2005.

Photograph by Kerry Grant

Tribal ties

Māori is a living culture, with whakapapa used as a knowledge or reference system through which both cosmological and genealogical narratives are expressed. Whakapapa expresses whanaungatanga or kinship between peoples, tribal areas, the natural environment and the interrelationship between all things, both animate and inanimate. Whakapapa recites relationships through time, space and generations. Even today, particular tribal adepts are responsible for ensuring that genealogical information is recited and used correctly.

Māori use whakapapa to identify themselves in relation to others and the world around them. The word 'iwi' derives from 'kōiwi', meaning 'bones' – a metaphor for the ties of genealogy. Iwi groups form the structure of Māori society today. They consist of various hapū, which in turn comprise groups of whānau. In the past, the most important political unit was the hapū.

The origins of the tribal groups lie in part with the waka that brought the first settlers – the founding ancestors. Since then, the groups have evolved as a result of conquests, alliances, disputes, marriages, migrations and land confiscations. Iwi boundaries were mapped only after expanded European settlement and introduced governance arrangements over land. Iwi boundaries and other grievances over land injustices are still being resolved today, through the Treaty of Waitangi process and through iwi and hapū negotiating directly with government.

While many Māori live in urban areas away from their tūranga-waewae – their tribal homeland, literally their 'place to stand' – ancestral ties remain important. Māori usually introduce themselves formally by identifying their iwi connections, which often include a sense of belonging to ancestral land. And when Māori recite their genealogy today, they often refer to the waka that brought their ancestors to Aotearoa.

Iwi regions in New Zealand for the taonga in this book

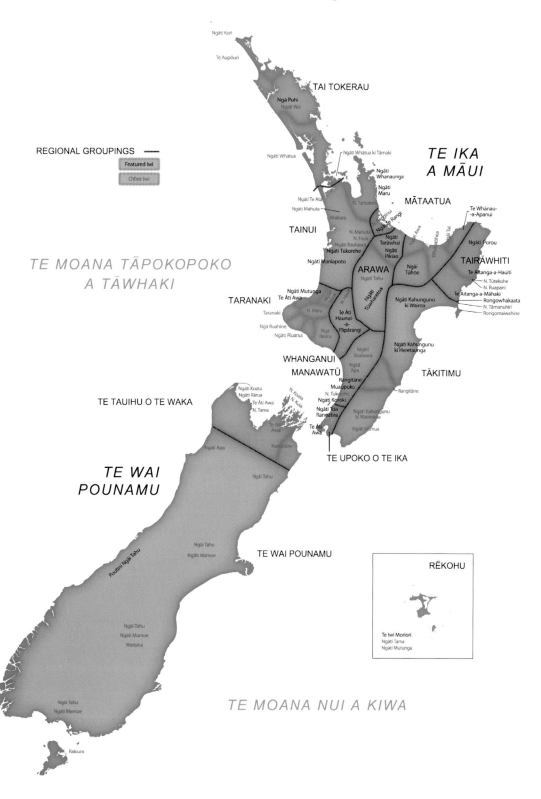

REGIONAL GROUPINGS ———

Featured Iwi

Other Iwi

Ngāti Kuri

Te Aupōuri

TAI TOKERAU

Ngā Puhi
Ngāti Wai

Ngāti Whātua

Ngāti Whātua ki Tāmaki

Ngāti Whanaunga

Ngāti Maru

Ngāti Te Ata

N. Tāmatera

Ngāti Mahuta

TE IKA A MĀUI

MĀTAATUA

Te Whānau-a-Apanui

Waikato

Ngāiterangi

TAINUI

N. Mahuta
N. Huia

Ngāti Tarāwhai

Ngāti Porou

Ngāti Raukawa

Ngāti Pikiao

Ngāti Tūkorehe

TAIRĀWHITI

Ngāti Maniapoto

ARAWA

Ngāi Tūhoe

Te Aitanga-a-Hauiti

Ngāti Tahu

N. Tūtekohe

Ngāti Mutunga
Te Āti Awa

TE MOANA TĀPOKOPOKO A TĀWHAKI

N. Ruapani

Te Aitanga-a-Māhaki

Rongowhakaata

TARANAKI

Taranaki

N. Maru

Ngāti Tūwharetoa

Te Āti Haunui-ā-Pāpārangi

Ngāti Kahungunu ki Wairoa

N. Tāmanuhiri

Rongomaiwahine

Ngā Ruahine

Ngāti Ruanui

Ngāi Reunu

Ngāti Raukawa

Ngāti Kahungunu ki Heretaunga

WHANGANUI

MANAWATŪ

Ngāti Apa

Rangitāne

Muaūpoko

N. Tukorehe

TĀKITIMU

Rangitāne

Ngāti Koroki

Ngāti Toa Rangatira

Ngāti Kahungunu ki Wairarapa

Ngāti Kaimua

Ngāti Koata
Ngāti Rārua

N. Koata
N. Kuia

Te Āti Awa

N. Tama

TE TAUIHU O TE WAKA

Te Āti Awa

Te Āti Awa

TE UPOKO O TE IKA

Ngāti Apa

Rangitāne

Ngāi Tahu

TE WAI POUNAMU

Poutini Ngāi Tahu

Ngāi Tahu

Ngāti Mamoe

TE WAI POUNAMU

RĒKOHU

Te Iwi Moriori
Ngāti Tama
Ngāti Mutunga

Ngāi Tahu
Ngāti Mamoe
Waitaha

Ngāi Tahu
Ngāti Mamoe

TE MOANA NUI A KIWA

Rakiura

This map shows the iwi regions where the taonga in this book come from. It is not a definitive map of iwi boundaries.

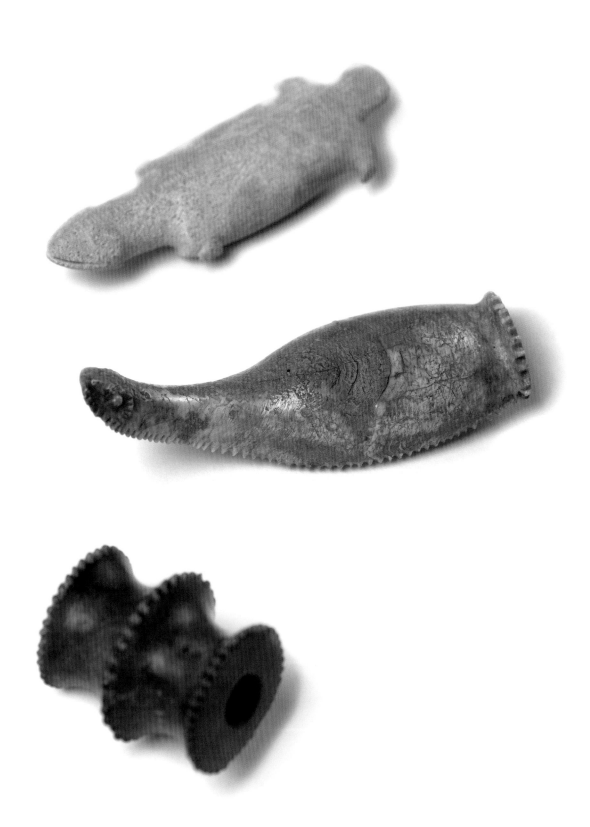

Taonga tawhito

Treasures from early times

The taonga tawhito (ancient treasures) reproduced in this book are thought to be from 500 to 900 years old. They date from the earliest period of settlement in Aotearoa. These taonga are important for at least two reasons: they are a link to ancestors and offer clues connecting Māori to the tropical Pacific islands they came from; and they show how the voyagers adapted to their new home and developed new forms.

The ancestral homeland of the Māori was in the region of the Cook, Society and Marquesas islands. These small tropical islands had limited resources – basalt for stone tools; sea mammal teeth, shell and bone for small objects such as fish-hooks and personal ornaments; and tropical plants for fibres to weave into mats, baskets and fishing nets, and to make cords and ropes.

By contrast, New Zealand was huge, with a much cooler climate and many natural resources. The new arrivals had to find these resources and learn how to use them. One of the first tasks was to repair or replace items essential for survival such as toki (stone adzes) and matau (fish-hooks). The settlers rapidly explored regions of the new country, searching for stone that could be worked into tools using the stone-working technology they were familiar with. They established manufacturing centres at places where suitable stone was found. Tools from these early centres became dispersed throughout the country – the characteristics of the stone have made it possible to trace this distribution. The early settlers must have also quickly discovered harakeke or New Zealand flax (*Phormium tenax*), which provided for another urgent need – fibre for cord and clothing.

One material that the new country lacked was mother-of-pearl shell, used in the tropical islands for fish-hooks and personal ornaments. As a substitute for this material, the settlers sometimes used stone for trolling lures, pendants and beads. Otherwise, they were able to use the same resources of the sea – other shells, the bones and teeth of sea mammals such as whales and dolphins, and the teeth of large fish.

Objects similar to the taonga tawhito pictured in this book have been found in archaeological excavations in both New Zealand and some of the tropical eastern Pacific islands, mostly dating from about 1100 to 1400 CE. They demonstrate the close connection between the settler ancestors of Māori and the islands from which they came. The magnificent stone adze blade, the large stone bead and the whale-tooth pendant are the most similar in form to objects found in the tropical Pacific. But each shows uniquely Māori features, reflecting rapid adaptations to the new environment.

The pendants brought to Aotearoa New Zealand by the first settlers were treasured possessions. They were not simply ornaments but were endowed with powerful spiritual properties. At first, the settlers made ornaments in the style of those they had brought with them. But in the new environment, styles began to change. By about 1500, new and distinctively Māori adornments were being made. Some of these changes came about through the discovery and use of new materials, such as pounamu (nephrite or greenstone). Some reflected new knowledge like the development of woodcarving. And some were probably simply changes in fashion. In fact, of the various styles of personal ornament brought from the Hawaiki of old, only the whale-tooth pendant survived into the times after Europeans arrived.

New-style pendant

This pendant, with its mix of styles, provides an important historical link between the Pacific and Aoteaora. It is made from a sperm whale's tooth, but little else is known about it. Although very similar in form to examples found in early archaeological sites in both the eastern Pacific and New Zealand, both the notching and the face at the tip are new. This pattern foreshadows the later forms with more distinctive facial features seen on pendants Māori were wearing when Europeans first arrived in New Zealand (an example of which may be seen on pages 102–3).

Hei kakī (pendant)

Ngā Kākano 1100–1300
Iwi unknown; from North Auckland region
Whale tooth / 107 x 36 x 19 mm
Purchased as part of the Spencer Collection, *c.* 1908

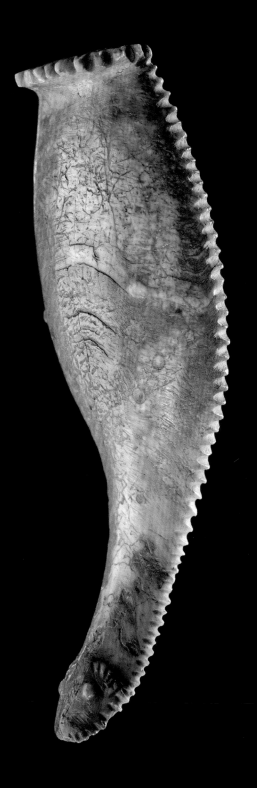

Shark-tooth adornment

A shark-tooth necklace of the kind pictured here was rare. The seven pieces in the necklace have been made from teeth of the great white shark. A large tooth features as a centrepiece and is surrounded by six smaller pieces. They are shaped at the base to fit neatly together. The great white shark is known as the mangō taniwha (both shark and supernatural being). Like all sea creatures it is a descendant of the sea god Tangaroa, and is admired by Māori for its legendary qualities of strength, speed and ferocity.

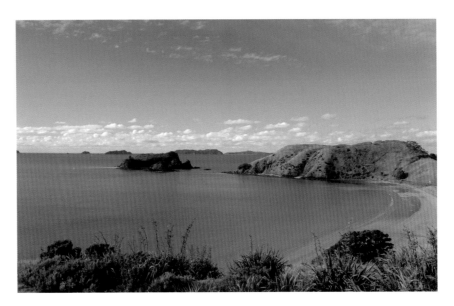

Opito, Coromandel, where the shark-tooth necklace opposite was found.

Photograph by Peter Quinn www.newzealandimages.co.nz

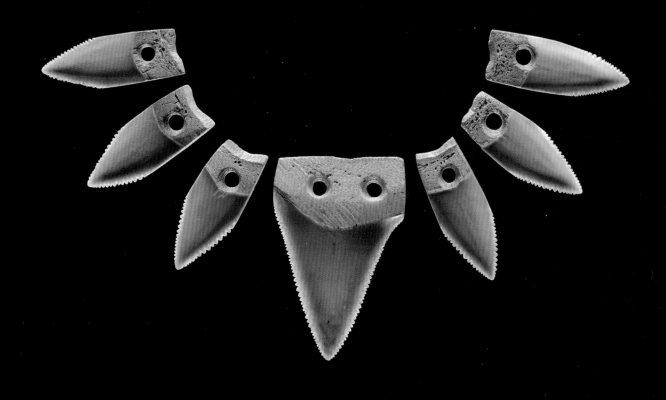

**Mau kakī niho taniwha
(shark-tooth necklace)**

Ngā Kākano 1100–1300 or Te Tipunga 1300–1500
Ngāti Hei, Ngāti Whanaunga; from Opito Beach, Coromandel region
Shark teeth / Estimated length 165 mm; 7 components from left to right:
32 x 12 x 4 mm; 31 x 12 x 4 mm; 31 x 12 x 4 mm; 43 x 29 x 6 mm;
31 x 12 x 4 mm; 32 x 11 x 5 mm; 31 x 12 x 4 mm

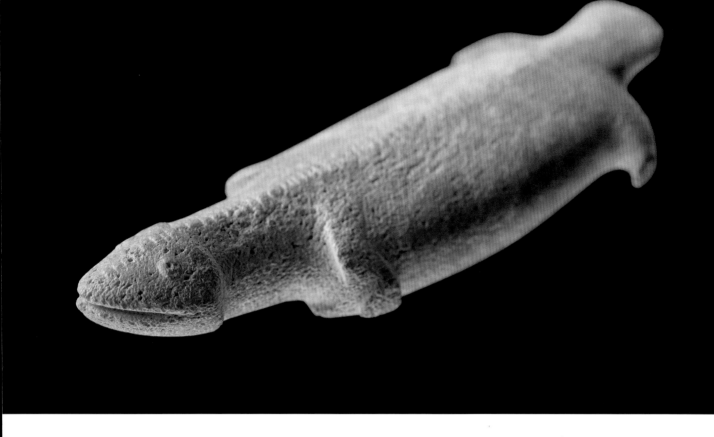

Ngārara (lizard)

Ngā Kākano 1100–1300 or
Te Tipunga 1300–1500
Iwi unknown; from Gisborne region
Whalebone / 100 x 16 x 31 mm
Purchased 1914

Lizard for protection

Ornaments in animal form are very rare, both in New Zealand and in the tropical Pacific islands. This ngārara (lizard) is made of whalebone, and was probably worn at the neck. It has a distinctive edge-notching pattern sometimes seen on tools and ornaments from the early periods of Māori settlement. An ornament shaped like an animal was believed to have the mauri of the animal it represented. A lizard might be a kaitiaki with powers of protection over the wearer.

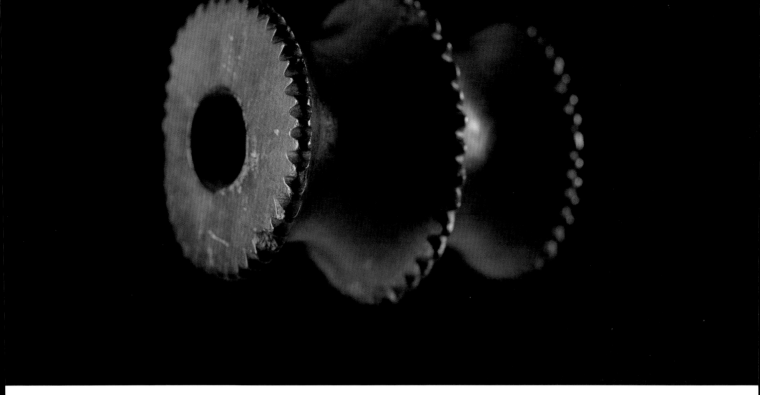

**Hei kakī
(stone bead pendant)**

Ngā Kākano 1100–1300
Iwi unknown; from Hawke's Bay region
Serpentinite / 35 x 35 x 65 mm
Purchased 1914

Stone heirloom

In New Zealand, stone beads like this were strung in necklaces. They could also be made out of sea mammal teeth or bone. A large bead may have been the centrepiece of a necklace, or worn alone as a pendant. This large stone bead was worn at the neck on a cord threaded through the bored hole. One side is flattened to lie against the wearer's chest. Māori today sometimes refer to these ornaments as iwi tuarā (human vertebrae) because of their shape. Some large beads were probably handed down for many generations, and the notching – which has not been found on similar personal ornaments in the tropical Pacific – added to represent these generations.

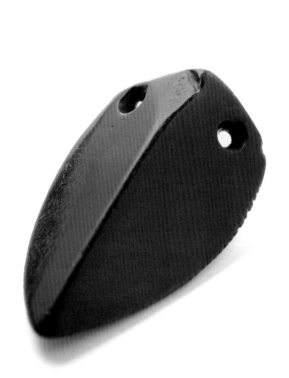

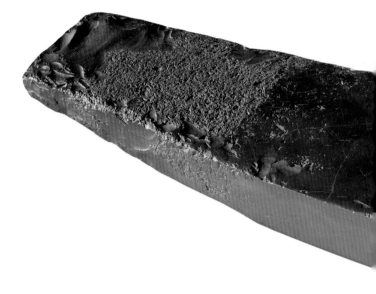

Hei kakī (pendant)
Ngā Kākano 1100–1300
Iwi unknown; from Waitōtara region
Serpentinite / 50 x 29 x 12 mm
Purchased 1905, as part of the
Handley Collection

Black stone pendant

This intriguing taonga has sometimes been interpreted as a representation of the green turtle, which occasionally ventures into New Zealand waters from the tropics. It may have been the centrepiece of a necklace, perhaps surrounded by beads. Such pendants are extremely rare. The stone it is made from, the way it has been worked, and the notching on the edges link it to other ornaments from the early period of Māori settlement. It comes from the Waitōtara region, where other important early taonga have been found.

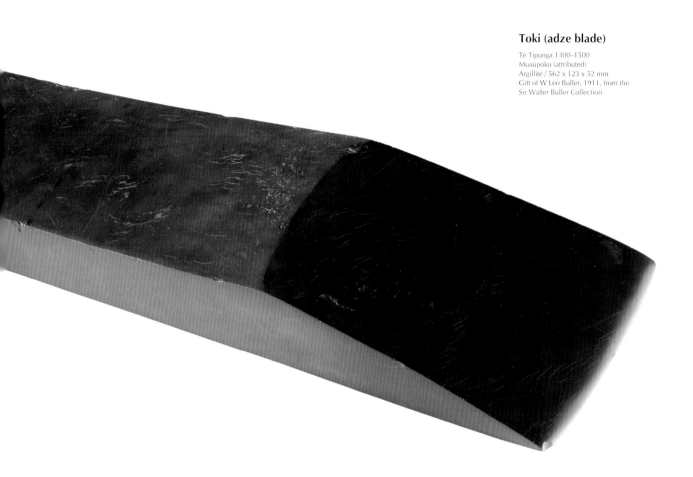

Toki (adze blade)

Te Tipunga 1300–1500
Muaūpoko (attributed)
Argillite / 562 x 123 x 52 mm
Gift of W Leo Buller, 1911, from the
Sir Walter Buller Collection

Work of a master

The toki was the most important tool for the first Māori settlers,
and featured in stories as ancient as those of the creation of the world.
Although this toki looks similar in shape to tools from the tropical
eastern Pacific, its shape and size have been influenced by new raw
material. It was made in New Zealand during the early period of settle-
ment. Only a master craftsman could make a blade of this size with such
precision. It has been flaked from its original rock, then ground smooth.
It would have been lashed to a wooden handle. Large toki were used for
felling trees and splitting timber. But a masterpiece like this may have
been used ceremonially – to make the first symbolic cut.

A new type of stone

The discovery of pounamu in remote parts of the South Island led to big changes in what could be made and how it was made. Pounamu is both beautiful and hard. It has quite different properties from the volcanic stones of the small Pacific islands from which the settlers had come.

At first, pounamu was used only for adzes and chisels. It took and held a very sharp cutting edge, which was excellent for woodcarving, but it had to be worked in a completely different way from the stones the first settlers chose for their tools. The first adze blades made in New Zealand were shaped by flaking, hammering and finally smoothing. Later, sawing and grinding were found to be more efficient ways of shaping the pounamu blades. The resulting tools were often simpler in shape and slightly different in proportion.

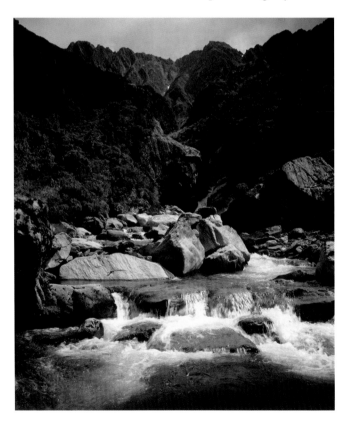

Arahura River, Westland – an important source of pounamu for Poutini Ngāi Tahu, the people of the South Island's West Coast.

The use of pounamu also revolutionised the styles of Māori personal adornment. Pounamu was too rare and precious for necklaces, and a new range of single pendants, worn at the neck or from the ear, was created to take advantage of its properties. Nothing is known of the history of the beautiful pendant opposite, which was repatriated from England in 1958. A few similar examples are thought to be representations of legs and feet. Because of its size, this taonga was probably worn at the neck, like a hei tiki (neck pendant in human form).

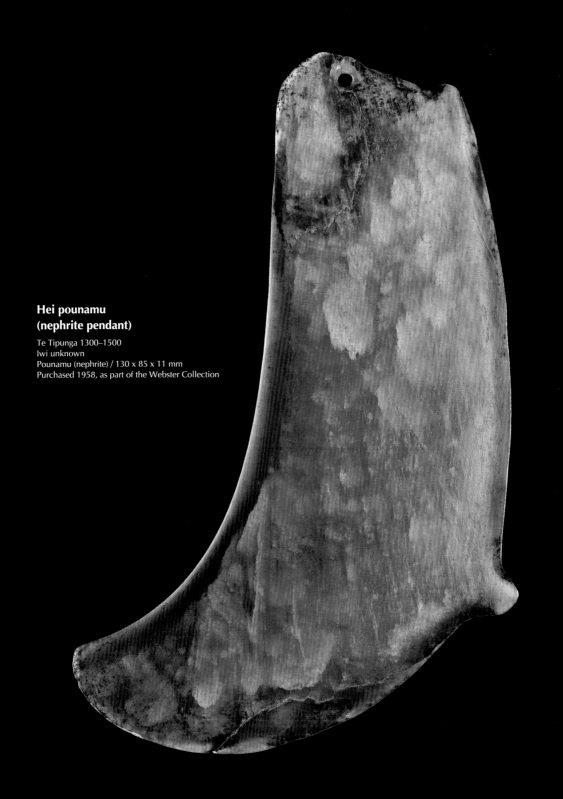

**Hei pounamu
(nephrite pendant)**

Te Tipunga 1300–1500
Iwi unknown
Pounamu (nephrite) / 130 x 85 x 11 mm
Purchased 1958, as part of the Webster Collection

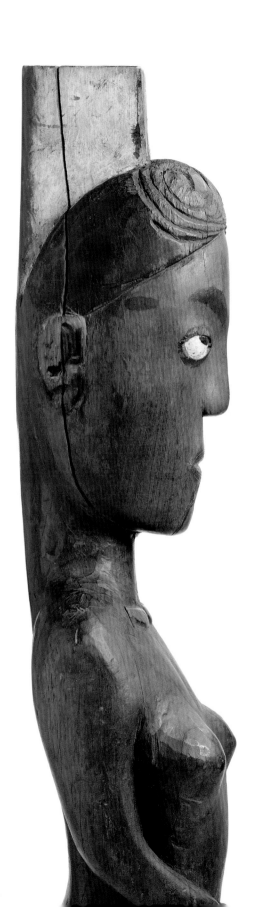
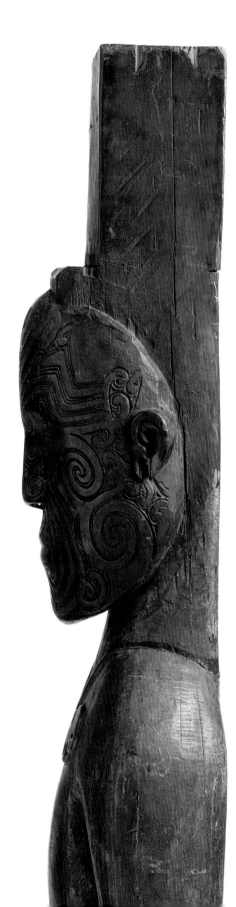

Waka, pātaka and wharenui

Statements of tribal identity

As Māori society developed, so did the carved structures that expressed identity. From the seventeenth century, the waka – and in particular the magnificent waka taua (war canoe) – was a key symbol of tribal pride and identity. Later, carved pātaka emerged as statements of authority and prestige. Then, in the nineteenth century, a time of extraordinary creativity and innovation, carved tribal wharenui became both the heart of Māori life and expressions of highly developed skill and artistry.

These taonga embody Māori cultural values, knowledge, histories and narratives. Some represent ancestors, while others are named in remembrance of significant historical events and occasions. Many evoke a powerful sense of the spiritual world in which they originated. They carry the mana of those who made them and the people for whom they were made. They have a mauri that transcends time, connecting past generations to those of the present and future.

Descendants of historic canoes

The way waka were designed and used evolved as a response to the unique conditions of New Zealand. The waka the first settlers arrived in were built to negotiate oceans and currents. In their new home, the settlers used the wealth of forest trees to develop single-hulled waka and smaller double-hulled waka for sea fishing and for transport.

The greatest of these waka were the magnificent waka taua. Waka taua were strategic assets for military expeditions along the extensive coastline and many inland waterways. They ranged from nine to thirty metres in length, and the largest could carry up to a hundred warriors. Building a waka taua was a major undertaking for the tribal community. Such vessels were invested with the prestige and spirit of the tribe's leaders and people.

Spiritual beliefs were integral to the making and sailing of waka. Tūmatauenga (god of war) is often depicted on the prow of a waka taua. Tūmatauenga alerts Tangaroa (god of the sea) that he is traversing the sea god's domain. Carving on the sternpost expresses the intimate relationships between the ira tangata (humanity) and the ira atua (the realm of the gods). Karakia or incantations to the gods were recited to ensure safe and productive journeys.

In 1990, twenty-one ceremonial waka taua were commissioned to mark 150 years of New Zealand nationhood since the signing of the Treaty of Waitangi. Skills both of building and of sailing waka were revitalised, and these contemporary waka became powerful symbols of tribal pride and identity. Today, interest in waka – paddled and sailed, in sheltered waters and in the ocean – and their traditions continues to flourish, both in New Zealand and throughout the Pacific.

Medium-sized replica waka taua on Wellington Harbour during the visit of the Prince of Wales to New Zealand in 1920.

Alexander Turnbull Library, F J Grant Collection PAColl-0362-01

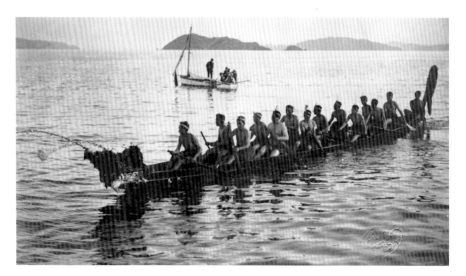

Watching over the crew

The taurapa (sternpost) provides spiritual protection and inspiration for the warriors who travel in the waka taua. The small figure sitting at this taurapa's base is an ancestral figure who watches over the crew. Two long ribs curve up from this figure. They symbolise the life forces of gods and of humankind. The spiral designs link warriors, ancestors and the Māori creation story. This taurapa was believed to be part of a famous waka named Kahutiaterangi. Te Rauparaha, a leader of Ngāti Toa, a North Island tribe, used it in his campaigns against South Island tribes in the 1830s.

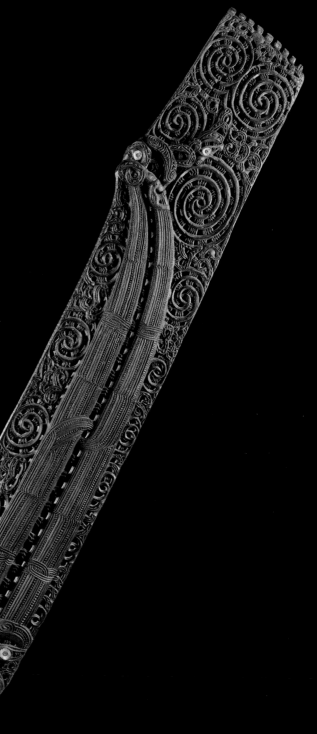

Taurapa (sternpost) from the waka taua (war canoe) called Kahutiaterangi

Early Te Huringa I 1800–1900
Ngāti Toa (attributed)
Wood, pāua shell / 2050 x 195 x 390 mm
Gift of the National Publicity Studios, 1981

Tauihu (canoe prow)

Late Te Puāwaitanga 1500–1800 or
early Te Huringa I 1800–1900
Ngāti Toa (attributed); from lower North Island
Wood, pāua shell / 1185 x 500 x 405 mm
Purchased 1958, as part of the Webster Collection

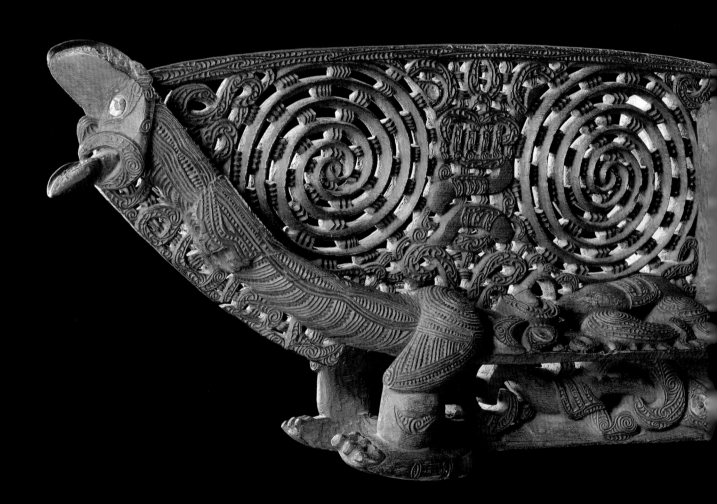

Finding safe passage

The tauihu (prow) was more than a beautifully carved figurehead on a waka taua. It was imbued with a mauri and charged with finding safe passage and keeping all on board unharmed. At the top of the tauihu opposite is the peaked head and protruding tongue of Tūmatauenga, the god of war. Two large carved spirals behind the head represent the space or world of light inhabited by parent deities of the Māori creation story, Ranginui (the sky father) and Papatūānuku (the earth mother). Elaborately and finely carved tauihu like this were carefully preserved when not in use. They became tribal heirlooms, passing from generation to generation.

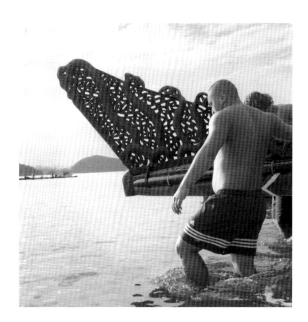

Early morning launch of a waka, Waitangi Beach, 6 February 2005.
Photograph by Mikel Taylor

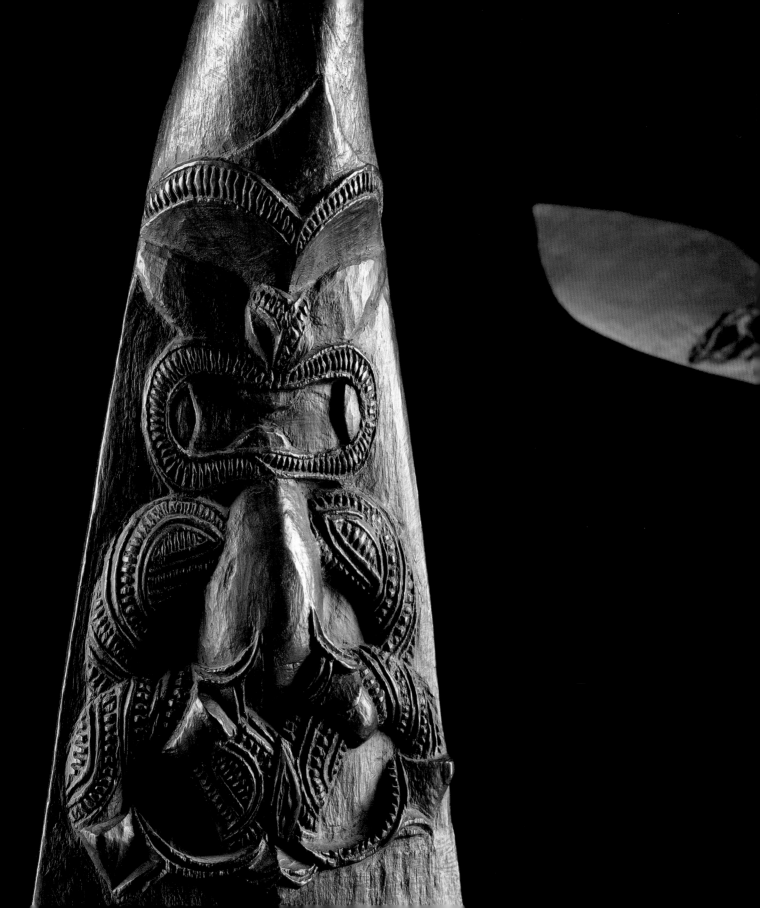

Beautiful and functional

A carved hoe (paddle) like this probably belonged to a person of rank. The cone-shaped head features in carving from Taranaki, possibly reflecting the region's domination by the volcanic cone of Mount Taranaki.

Hoe (paddle)

Late Te Puāwaitanga 1500–1800
Te Āti Awa, Ngāti Mutunga (attributed); from Taranaki region
Wood / 1439 x 146 x 85 mm
Purchased 1958, as part of the Webster Collection

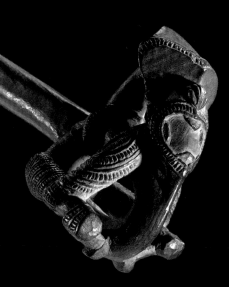

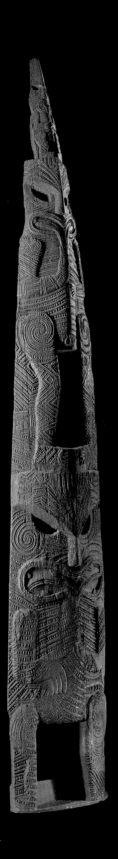
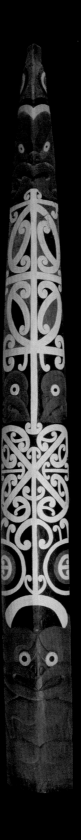

**Waka whakamaumaharatanga
(canoe cenotaph)**

Left to right:

Early Te Huringa I 1800–1900
Te Āti Haunui-ā-Pāpārangi; from
Whanganui region
Wood, paint / 5490 x 860 x 600 mm
Gift of W Leo Buller, 1911, from the
Sir Walter Buller Collection

1906, Te Huringa II 1900–1960
Made by Neke Kapua (Ngāti Tarāwhai)
Wood, paint / 7320 x 670 mm

Memorial to a chief

The waka is a powerful symbol for Māori. Waka hourua carried their ancestors to New Zealand. Waka taua transported warriors to battle, and carried the slain back to their tribal homes. This link with death gave a waka taua further spiritual significance. A waka associated with a chief was a symbol of prestige and authority. A chief's waka was often dismantled on his death, and the hull carved and erected in his honour.

The towering memorial opposite (left) is made from a section of a waka hull called Te Koanga o Rehua. It was erected early in the nineteenth century for Te Mahutu, a chief from Te Āti Haunui-ā-Pāpārangi of the western North Island. The hull is carved with three ancestral guardians. They would guide the spirit of the dead chief back across the ocean to his ancestral home of Hawaiki.

The memorial was relocated twice. It then collapsed when the base rotted. It was left untouched because of its association with death. Finally it was retrieved by the famous chief and soldier Te Keepa Te Rangihiwinui. He presented it to his friend, the naturalist Sir Walter Buller, who erected it on his estate in memory of Te Rangihiwinui's ancestor. Buller's descendants donated the memorial to the national museum.

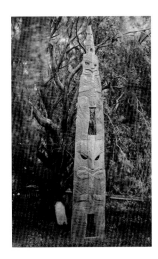

Canoe hull memorial for Te Mahutu in place at Pipiriki, Whanganui River, 1860–90.

Photograph by William James Harding
Alexander Turnbull Library 1/4-017135-G

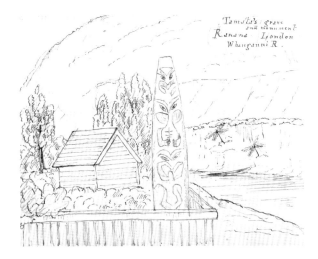

Canoe hull memorial marking Tamata's grave, Ranana, Whanganui River, 1861.

Pencil and ink drawing by James Coutts Crawford
Alexander Turnbull Library E-041-026

A chief's storehouse

Ko te tohu o te rangatira he pātaka whakairo e tū ana
i roto i te pā tūwatawata.
*The sign of a chief is a carved storehouse standing inside
a fortified village.*

For a time, carved pātaka were key symbols of tribal identity, and state-
ments of influence and prestige. In the eighteenth and nineteenth centuries,
villages had a large pātaka often erected close to the leading chief's dwelling.
A large pātaka expressed the mana and wealth of a hapū or iwi. It showed
that the people could care for and feed both themselves and their guests.
It also demonstrated a leader's ability to protect people, sustain their health
and safely store treasured items or food delicacies. Few people were allowed
access to the interior of a pātaka.

Pātaka were built on piles or posts to give protection from rats and
were used to store specialised and preserved food such as potted birds and
dried fish. On occasion, these structures were used to store weapons, cloaks
and other taonga. Some were richly carved.

During intertribal conflict, some pātaka were dismantled and hidden
in swamps and caves for fear that the carvings would be taken by the victors.

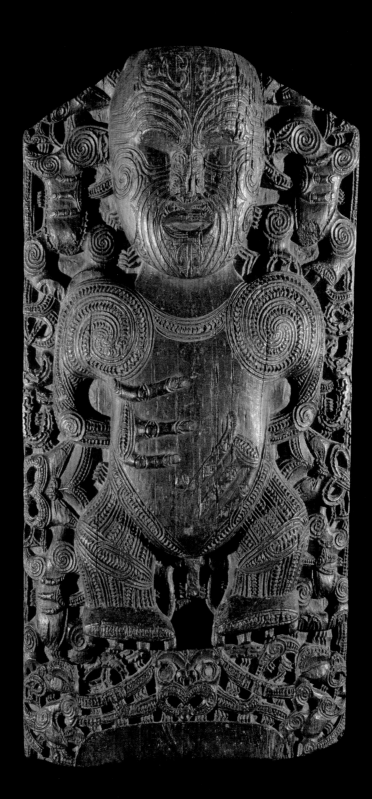

**Kūaha pātaka
(storehouse doorway)**

Early Te Huringa I 1800–1900
Ngāti Kahungunu or East Coast
iwi (attributed)
Tōtara wood (with traces of
pigment) / 920 x 450 x 130 mm
Acquired 1948, as part of the
Oldman Collection

The story of Te Awhi pātaka

The pātaka pictured here and overleaf was originally built by the Ngāti Pikiao tribe of the central North Island. It was first named Pukehina, and later Te Awhi. The timber for this building is said to have come from a large canoe abandoned in a river in 1823. Sixteen years later, seven chiefs used the wood from the canoe to construct the pātaka, which they built to accompany a large carved house at Maketū, in the north-eastern North Island.

In 1911, the national museum bought this pātaka from Ngāti Pikiao. In exchange, the museum arranged for a new pātaka to be made for Maketū. Parts of the original building had deteriorated, and replacement panels were made by a carver employed by the museum.

Pātaka carvings depict important relationships between people, the land and the resources around them. One prominent feature of this pātaka is the representation of a whale being hauled ashore by several figures. Whales were a rare gift from the sea. They were a great bonus as they were a rich source of food and bone. The stylised whale carved on these bargeboards is a symbol of leadership and sustenance.

Pukehina / Te Awhi pātaka,
c. 1885.

Photograph by Burton Brothers

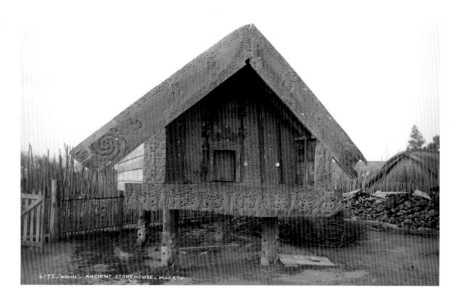

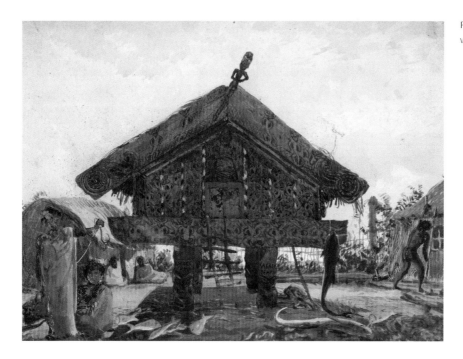

Pukehina / Te Awhi pātaka, 1864.

Watercolour by Horatio Robley

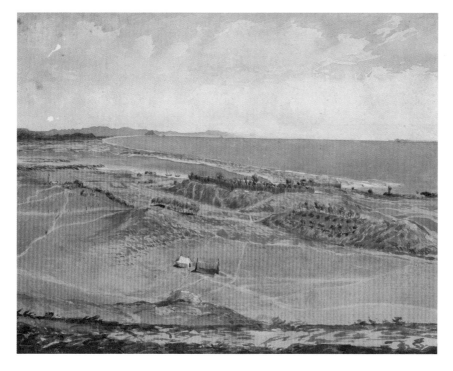

Maketū pā, Bay of Plenty, 1865.

Watercolour by Horatio Robley

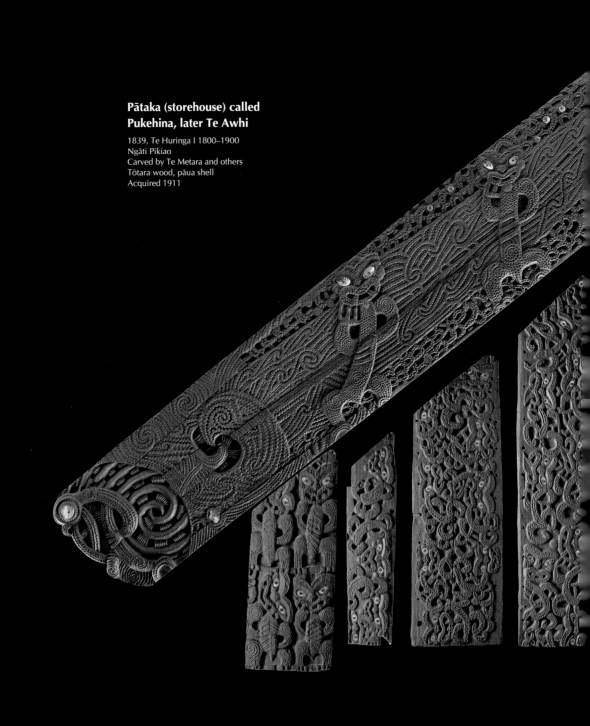

**Pātaka (storehouse) called
Pukehina, later Te Awhi**

1839, Te Huringa I 1800–1900
Ngāti Pikiao
Carved by Te Metara and others
Tōtara wood, pāua shell
Acquired 1911

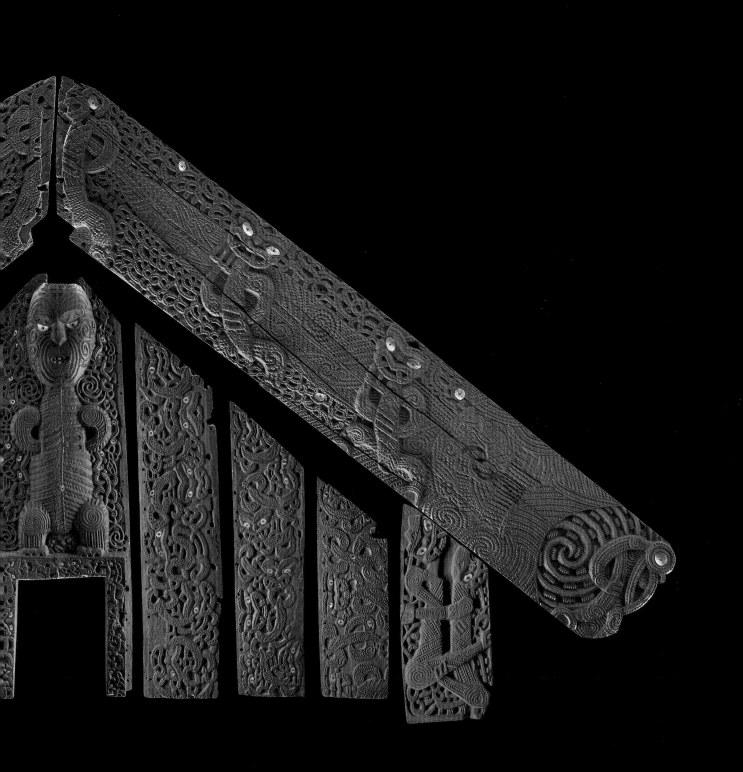

**Kūaha (doorway) of
Pukehina / Te Awhi pātaka**

1710 x 670 x 120 mm

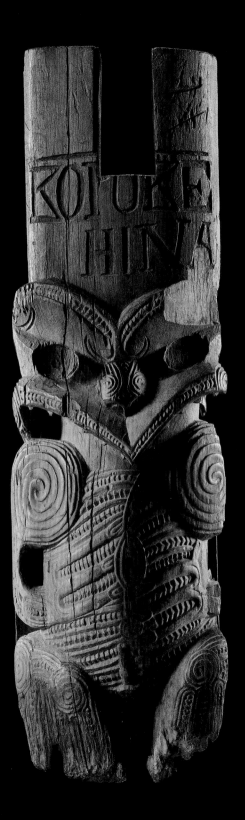

**Pou aronui (support pole) of
Pukehina / Te Awhi pātaka**

990 x 300 x 200 mm

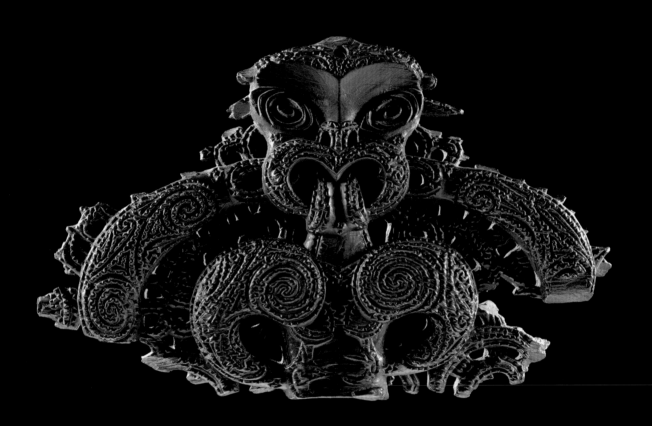

Pare (door lintel) fragment

Te Puāwaitanga 1500–1800 or early
Te Huringa I 1800–1900
Te Whānau-a-Apanui (attributed)
Wood / 276 x 450 x 55 mm
Purchased 1958, as part of the Webster Collection

The ancestral meeting house

In the nineteenth century, a time of great creativity and innovation, carved tribal wharenui became both the heart of Māori life and expressions of highly developed skill and artistry. The wharenui mostly surplanted the waka and later the pātaka as the principal symbol of tribal identity.

The wharenui is still an important part of a marae (communal centre). It is used for family celebrations and funerals, as well as for gatherings to discuss significant issues and tribal affairs. The wharenui is perhaps the most powerful symbol of Māori cultural identity today. It reflects the relationship of the people to the land, its history and its resources. It also tells of the genealogies of its peoples. These cultural elements are communicated through the forms of its architecture, including the whakairo (carvings), kōwhaiwhai (painted scroll ornamentation) and tukutuku (woven lattice work).

Carved wharenui date from the late eighteenth century and are mentioned in the accounts of the early European explorers. The building itself represents the body of an ancestor, with the ridgepole likened to the backbone, and the rafters as the ribs. Many wharenui are named after an important tribal ancestor. When you enter a wharenui, you know that you are surrounded by ancestors and history.

Since the mid nineteenth century there has been an explosion in the size, visual language and function of wharenui. Today there are around one thousand in use as communal meeting places throughout New Zealand. They are carved and uncarved, large and small.

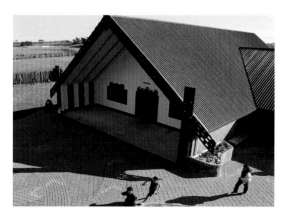

Ngākaunui meeting house at
Aotearoa Marae, South Taranaki

Photograph by James Heremaia

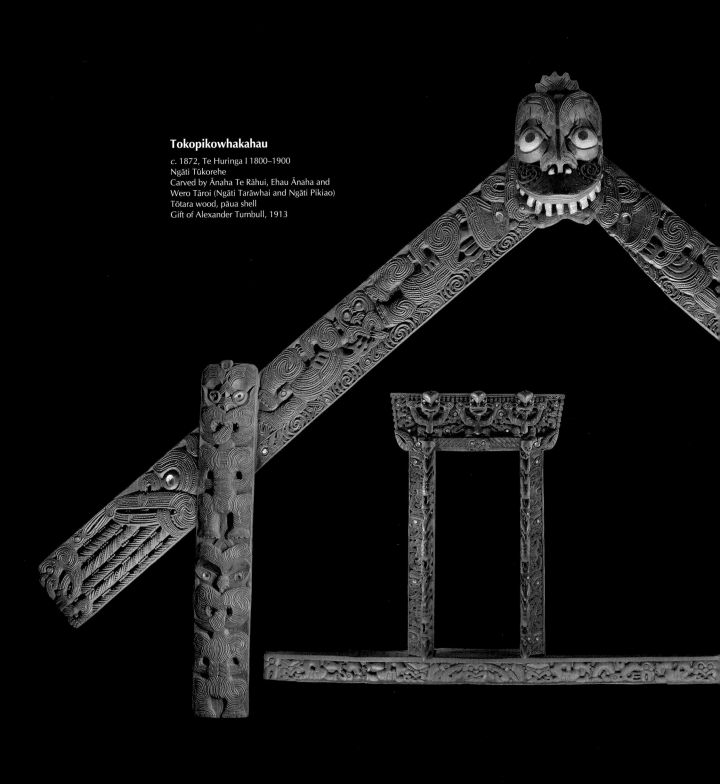

Tokopikowhakahau

c. 1872, Te Huringa I 1800–1900
Ngāti Tūkorehe
Carved by Ānaha Te Rāhui, Ehau Ānaha and
Wero Tāroi (Ngāti Tarāwhai and Ngāti Pikiao)
Tōtara wood, pāua shell
Gift of Alexander Turnbull, 1913

Tokopikowhakahau is a partly reconstructed whare tupuna (ancestral meeting house), named after an ancestor who links the North Island tribes Ngāti Tūkorehe and Ngāti Raukawa. Here you see key parts of the house's front. The koruru (gable carving) represents the ancestor's head. The maihi (bargeboards) that stretch out from the koruru are the ancestor's embracing arms. The amo (front posts) supporting the maihi represent later ancestors. Behind the house's porch are the kūaha (doorway) and the paepae (threshold beam). These mark the boundary between the outside and the inside of the house – two significant spaces for Māori.

The area in front of a meeting house is the place of Tūmatauenga, the god of war. It is the zone of confrontation, active debate and whaikōrero (oratory). Inside the house is the place of Rongomātāne, the god of peace. Those who cross the paepae and pass through the doorway enter a zone of harmony and conciliation.

The story of Tokopikowhakahau

Tribal leader Karanama Te Akatuku commissioned the house to be built at Tāpapa in the Waikato region of the North Island. Three carvers were invited to carve the house in 1877–78. They were paid £500, received traditional treasures and were well looked after by the tribe.

When it was built, Tokopikowhakahau was a symbol of tribal pride, with its powerful carvings and the beautiful woven wall panels of its interior. However, the succeeding two decades were depressed times for Māori. By the early twentieth century the house was derelict. The carvings were removed and sold to a private collector before being presented to the national museum in 1913.

Tokopikowhakahau arouses many emotions among those closely connected to it. There is also sadness that the house resides in a museum collection, not as part of a living community. The mauri of this house as a tribal ancestor of Ngāti Tūkorehe remains strong. Continuing research and discussion between the museum and iwi will enliven and preserve its past for present and future generations.

Tribal descendants farewell Tokopikowhakahau meeting house on its departure for Asia at a ceremony at Waikato Museum of Art and History, 12 June 2006.
Waikato Times

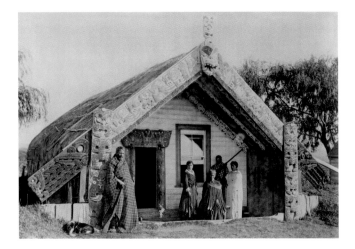

Tokopikowhakahau meeting house at Tāpapa, near Okoroire, Waikato region, with Āperahama Taipōrutu, the chief at that time (left), and his family, c. 1885.

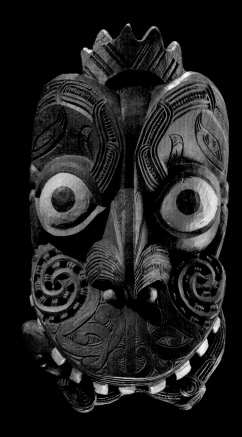

Koruru (gable carving)
of Tokopikowhakahau

1170 x 670 x 300 mm

Pare (door lintel)
of Tokopikowhakahau

1475 x 490 x 89 mm

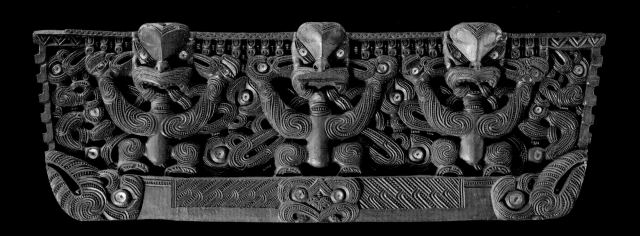

Central to the house

Structural elements inside the wharenui also represent the ancestral body. Standing in the centre of a meeting house are pou tokomanawa (central support posts). They extend up to the ridgepole that supports the roof. Many pou tokomanawa have a male or female ancestor carved at the base.

The two carved figures opposite are similar in style, though they came from different meeting houses. The figures exemplify the male and female principles in the Māori world. The female pou tokomanawa symbolises the power to give birth and sustain life. The male figure emphasises the power of procreation: one hand grips his genitals, while the pendant around his neck links him to his ancestors.

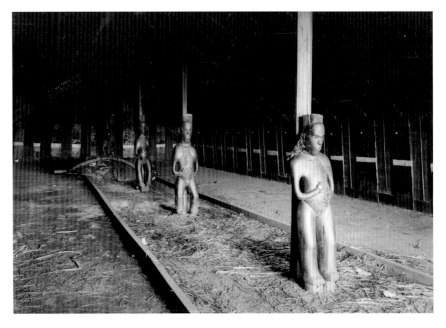

Pou tokomanawa in the Heretaunga ancestral meeting house, Ngāti Pārau, Hawke's Bay region, 1879–90.

Photograph by Samuel Carnell
Alexander Turnbull Library 1/1-019393-G

Pou tokomanawa (female post figure)

Te Huringa I 1800–1900
Ngāti Kahungunu; from Wairoa region
Tōtara wood, pigment, shell / 1160 x 230 x 200 mm
Gift of Mrs Wade, 1950

Pou tokomanawa (male post figure)

Te Huringa I 1800–1900
Ngāti Kahungunu; from Wairoa region
Tōtara wood, paint / 1240 x 220 x 185 mm
Purchased 1905, as part of the Hill Collection

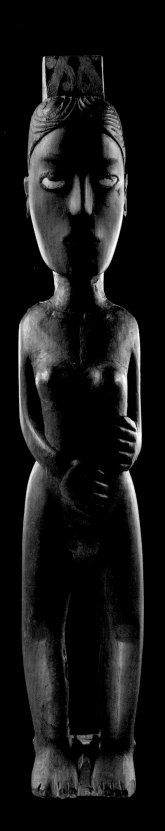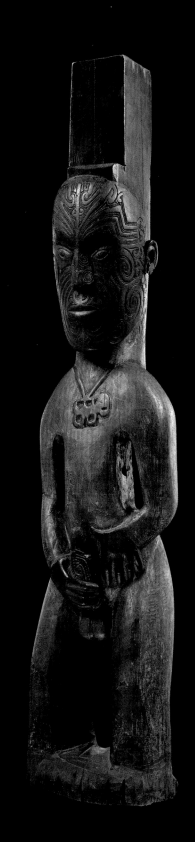

A chief of great stature

Elements of whakairo are used in other architectural contexts. Similar to the poupou (upright post) or the pou tokomanawa of a wharenui, the two massive posts pictured opposite and overleaf were part of a memorial. The monument was erected to the memory of paramount chief Te Heuheu Tūkino II, of the Ngāti Tūwharetoa tribe in the central North Island. Te Heuheu was one of the most influential leaders in nineteenth-century New Zealand history. His memorial was as imposing as the man it honoured. Te Heuheu was a man of huge physical stature. English artist George French Angas described him as 'a fine old man with an imposing appearance and dignified carriage; he stands nearly seven feet high . . . His hair is silvery white and his people compare it to the snowy head of the sacred [mountain] Tongariro.' [1]

Te Heuheu died in 1846. His younger brother, Iwikau Te Heuheu Tūkino III, the next paramount chief, carved the memorial. Iwikau's successor, Horonuku Te Heuheu Tūkino IV, gifted the mountain Tongariro to the nation on behalf of his iwi, Ngāti Tūwharetoa. It formed the central part of New Zealand's first national park.

Monument to Te Heuheu Tūkino II Mananui at Pūkawa, Taupo, erected by his brother, Iwikau. In this sketch (c. 1847), the pou tokomanawa (opposite, right) is one of two tall upright support figures in the foreground. The large ancestral figure (opposite, left) may be represented by one of three background figures.

Detail from pencil, ink and watercolour sketch by Reverend Richard Taylor Alexander Turnbull Library E-296-q-155-4

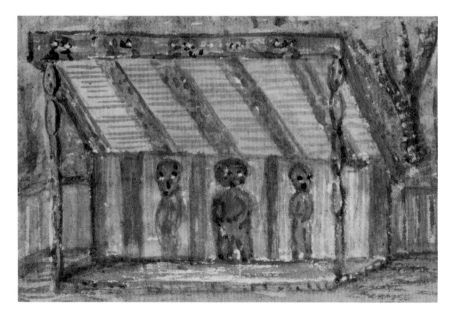

Amo (bargeboard support post) or poutuarongo (rear support for ridgepole) of memorial

1850, Te Huringa I 1800–1900
Ngāti Tūwharetoa
Carved by Iwikau Te Heuheu Tūkino III
Tōtara wood, paint / 2580 x 585 x 218 mm
Gift of Tūreiti Te Heuheu Tūkino V, 1912

Pou tokomanawa (male post figure) for memorial

Full image at right, details overleaf

1850, Te Huringa I 1800–1900
Ngāti Tūwharetoa
Carved by Iwikau Te Heuheu Tūkino III
Tōtara wood / 3890 x 320 x 230 mm
Acquired 1912

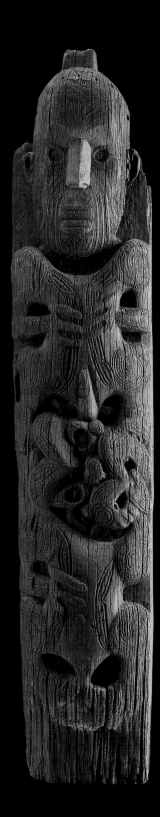
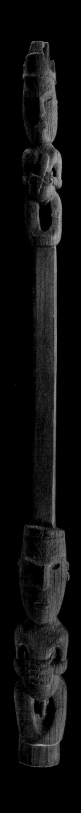

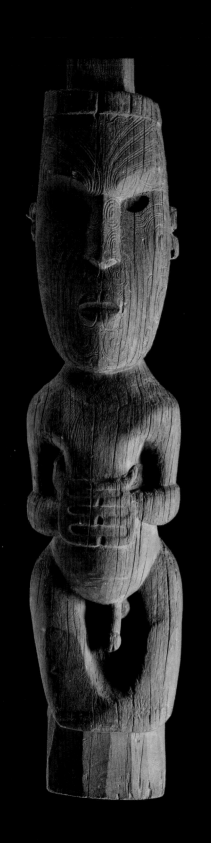
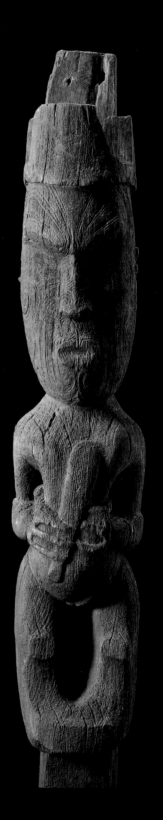

Tradition and innovation

This figure formed the base of a pou tokomanawa and represents an important ancestor of the East Coast tribes of the North Island. It has the customary stance of an ancestor, with the hands resting on the stomach. The head is elongated – a symbol of its utmost sacredness – and features the topknot commonly worn by chiefs of the era. The carving on the face, thigh and buttocks imitates the tattooing on the skin of a living person. The figure once belonged to Wiremu Halbert Pere, a high-ranking chief and one of the first Māori members of the New Zealand Parliament.

Pou tokomanawa (male post figure)

Te Huringa I 1800–1900
Rongowhakaata, Te Aitanga-a-Māhaki; from Gisborne region
Wood, paint, pāua shell / 1230 x 400 x 240 mm
Purchased 1920

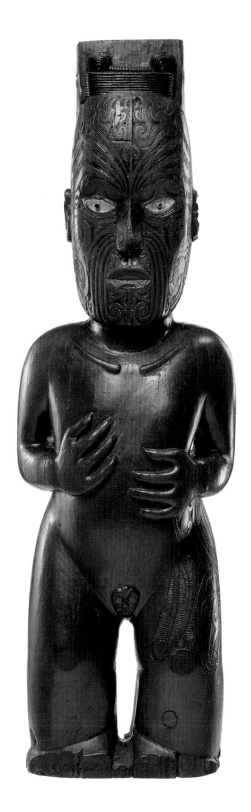

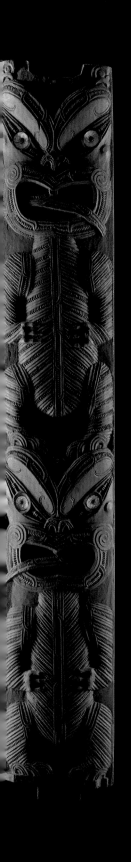

Named after a chief

One ancestral figure stands above another in this poupou. Poupou form part of the inside walls of the meeting house, and they support the physical structure of the building. Carvings on poupou often embody tribal stories about ancestors or significant battles or other historical events. This poupou was carved for a meeting house named after the East Coast chief Te Kani-a-Takirau, a monumental figure in Māoridom in the nineteenth century. He exercised authority over a large area of the eastern North Island.

Poupou (post) from Te Kani-a-Takirau meeting house

1881, Te Huringa I 1800–1900
Te Aitanga-a-Hauiti; from Tolaga Bay
Carved by Hōne Ngātoto (Ngāti Uepōhatu, Ngāti Horowai, Te Whānau-a-Ruataupare, Te Whānau-a-Te Ao)
Tōtara wood, pāua shell / 2100 x 340 x 30 mm
Purchased as part of the Fischer Collection *c.* 1904

Keeping watch

This carved figure originally stood as a
sentinel on top of a pou whakarae (stockade
post). The post formed part of a palisade
around a fortified position. Tribes needed
to protect themselves from their rivals
and enemies. They fortified pā (strategic
positions and villages) by surrounding them
with palisades. These often included massive
hardwood posts, topped with carvings that
represented tribal ancestors. The carved
posts of the pā were an expression of the
strength and defiance of its occupants.

**Pou whakarae
(stockade post)**

Late Te Puāwaitanga 1500–1800
or Te Huringa I 1800–1900
Ngāi Tūhoe
Wood / 1130 x 230 x 190 mm
Acquired 1911

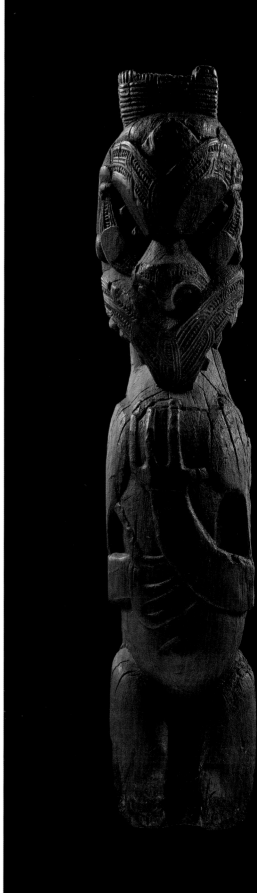

**Epa (panel) from
unknown meeting house**

Te Huringa I 1800–1900
Iwi unknown
Tōtara wood, pāua shell / 2260 x 590
x 70 mm (left), 2240 x 570 x 60 mm (right)
Gift of the New Zealand High Commission,
London, 1953

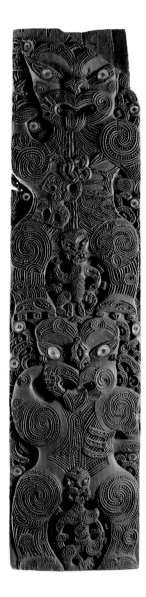
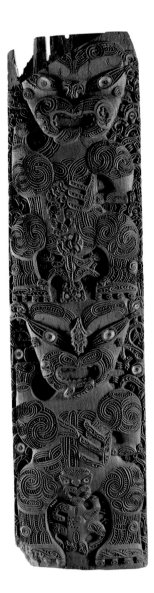

Carved stories

These epa (panels) were possibly carved for a meeting house or a
Christian church. They were designed for the inside front or back wall.
The top of each panel is angled to fit into the back board below the rafters.
Carvings on epa often represented important cultural stories relevant to
the tribe. The original stories shown in these epa are currently not known,
as the carvings have been away from a tribal context for so long.

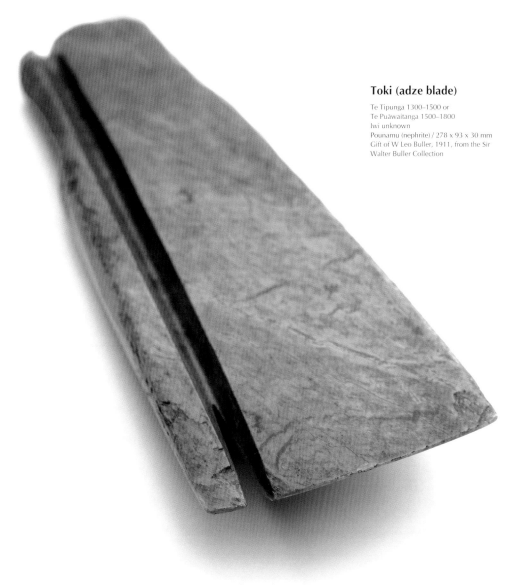

Toki (adze blade)

Te Tipunga 1300–1500 or
Te Puāwaitanga 1500–1800
Iwi unknown
Pounamu (nephrite) / 278 x 93 x 30 mm
Gift of W Leo Buller, 1911, from the Sir
Walter Buller Collection

The finest adzes

Toki were vital tools in the construction and carving of waka, pātaka
and wharenui. The most prized blades were made of pounamu – highly
valued in tools for its hardness and ability to take and keep a sharp edge.
Pounamu toki were cut to shape with sandstone, quartz or greywacke saws
and files, and then polished. This process took some days or even weeks,
depending on the size of the toki.

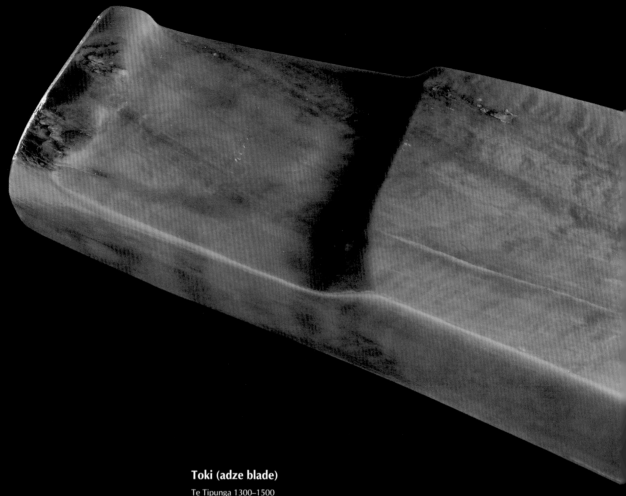

Toki (adze blade)

Te Tipunga 1300–1500
Iwi unknown
Pounamu (nephrite) / 562 x 123 x 52 mm
Purchased 1948, as part of the Oldman Collection

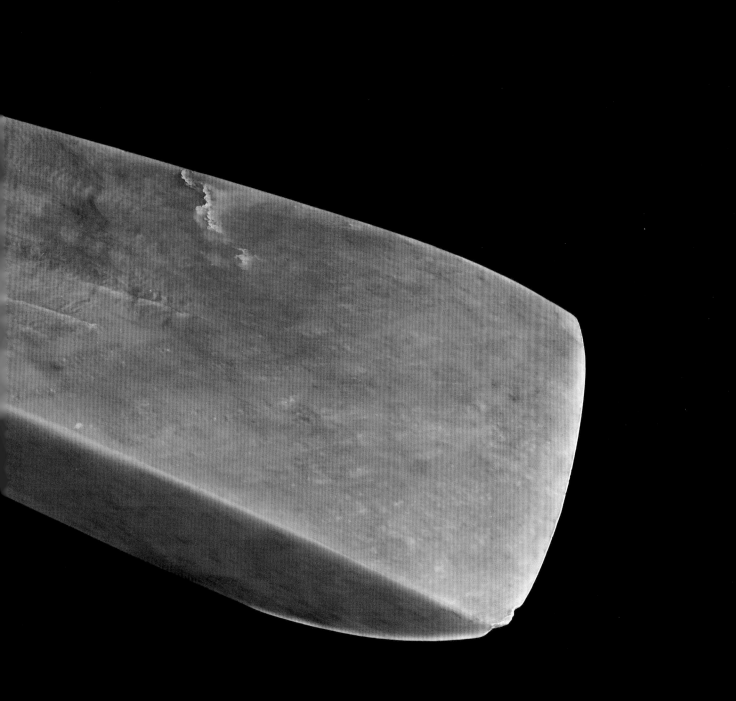

Stone tools

The shape of this toki makes it very strong, suitable for tasks such as cutting and finishing timber for meeting houses. The toki is made of greywacke, a hard stone frequently used for tools and weapons, or for cutting and filing pounamu. With the arrival of metal tools the practice of making and using stone tools abated. Today, a small yet growing number of people are reviving this ancient art – keeping this connection to their ancestors alive.

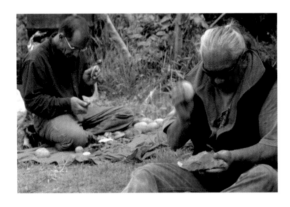

Adze-making exponents Dante Bonica and Leighton Hale (Ngāti Hinewaka), flaking adzes at a toki-making workshop, Hongoeka marae, Plimmerton, 2004.

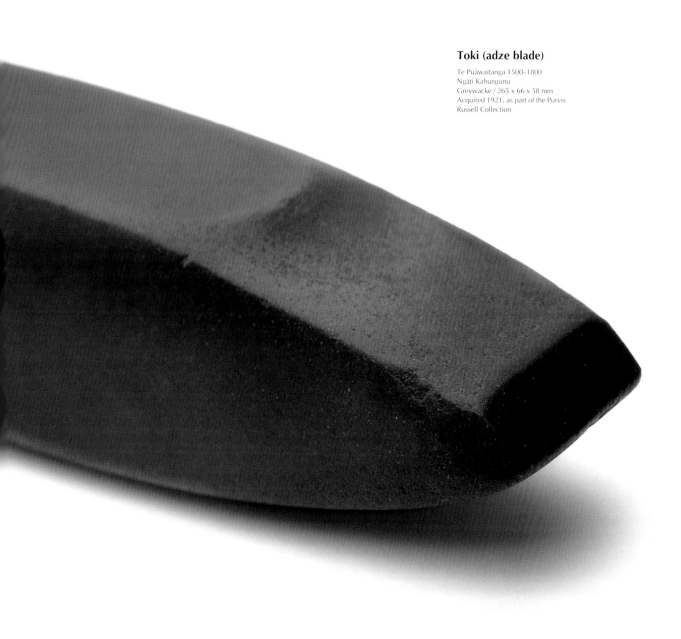

Toki (adze blade)

Te Puāwaitanga 1500–1800
Ngāti Kahungunu
Greywacke / 265 x 66 x 58 mm
Acquired 1921, as part of the Purvis
Russell Collection

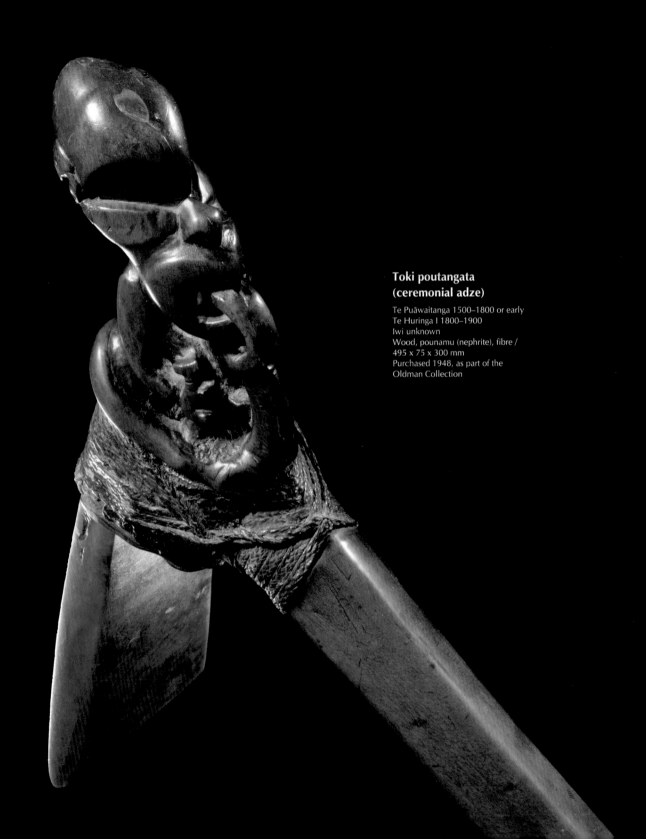

**Toki poutangata
(ceremonial adze)**

Te Puāwaitanga 1500–1800 or early
Te Huringa I 1800–1900
Iwi unknown
Wood, pounamu (nephrite), fibre /
495 x 75 x 300 mm
Purchased 1948, as part of the
Oldman Collection

A ceremonial adze

Certain rituals had to be carried out when a large tree was felled for use as a war canoe, ridgepole in a meeting house, stockade post or cenotaph memorial. Felling of large trees was a serious matter, as trees were believed to embody Tāne Mahuta, god of the forest. In such cases, karakia 'cleared the way' for the tree to be taken out of the forest. A chief might use a toki poutangata (ceremonial adze) to make the ritual first cut to the tree. The chips of wood from the first cut were offered with prayers of thanksgiving to Tāne Mahuta. Toki poutangata are made of the finest materials. They are tribal heirlooms, given personal names, and sometimes credited with spiritual powers. Contemporary carvers still use a toki poutangata to make the ritual first cut for a new work.

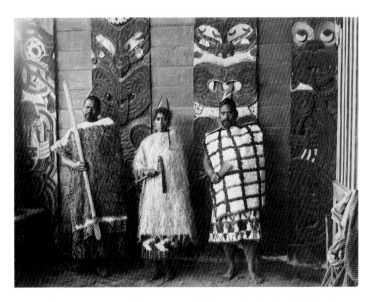

Hūrae Puketapu, Te Kopa (holding a ceremonial adze) and her husband Te Huatahi on the porch of Te Whai-a-te-motu meeting house, Mātaatua marae, Ruatāhuna, Urewera region, c. 1905.

Photograph by W A Neale
Alexander Turnbull Library, A H Brooke-Taylor Collection PAColl-1767-2

Master carver Paki Harrison (Ngāti Porou), holding his toki poutangata, 1994.

Photograph by Sally Tagg
Sally Tagg / Mana magazine

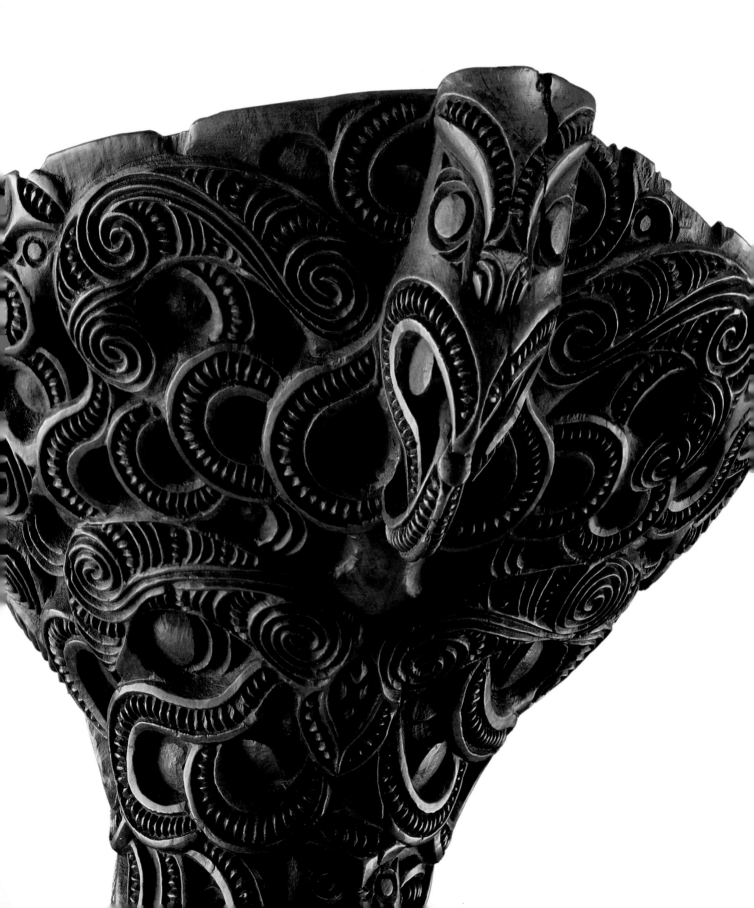

CHAPTER 3

Tā moko

Carving the skin

Tāia ō moko, hai hoa matenga mōu.
Your moko will accompany you forever.

Cultural identity was expressed not only through large carved structures
and objects of personal adornment. It was also expressed through tā moko
– the traditional Māori practice of tattooing by cutting the skin, then
staining it with dark pigment. Eastern Pacific peoples patterned the skin
by puncturing it. Māori adapted this technique, making a grooved channel
in the skin similar in appearance to woodcarving. In the carving tradition,
moko patterns were also applied to a range of ceremonial, structural or
special small items.

The origins of tā moko lie in the legend of Mataora and his wife
Niwareka. Mataora (whose name means 'living face') mistreated
Niwareka, who fled to her parents in the underworld, where Mataora
pursued her. Her father, an expert in tattooing, looked with disdain on
Mataora's unmarked skin and forcibly tattooed his face. Niwareka helped
him to heal. When Mataora returned to this world, he brought the art of
tā moko with him.

In recent years, there has been a renewed interest in moko. Both
customary and contemporary techniques are used to apply it and as in the
past, mainly the face, back, buttocks and thighs are patterned. Increasing
numbers of Māori are choosing to have moko applied, and pride in this
art form is growing. Moko continues to mean what it has always meant: it
is a symbol of integrity, Māori identity and pride, as well as a reflection of
whakapapa and history.

Feeding funnel

Tapu regulated almost every aspect of Māori life from birth to death. Although it was generally observed in restrictions on behaviour, tapu also had a protective role, ensuring that everyday tasks were done safely. People involved in ceremonial rituals, such as tattooing, were placed under extreme restrictions of tapu. These safeguarded the spiritual practices of tattooing, but also ensured that it was carried out in a hygienic way. A kōrere (feeding funnel), for example, was used to feed a high-ranking person whose face was swollen and painful after receiving a moko. The funnel helped protect the open wounds of the face from infection through contact with food or human touch.

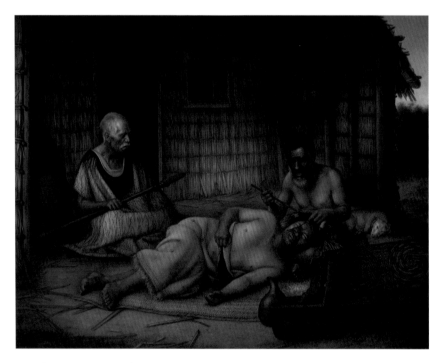

The Tohunga-ta-moko at Work

Oil paint on canvas by Gottfried Lindauer
Auckland Art Gallery Toi o Tāmaki, gift of Mr H E Partridge, 1915

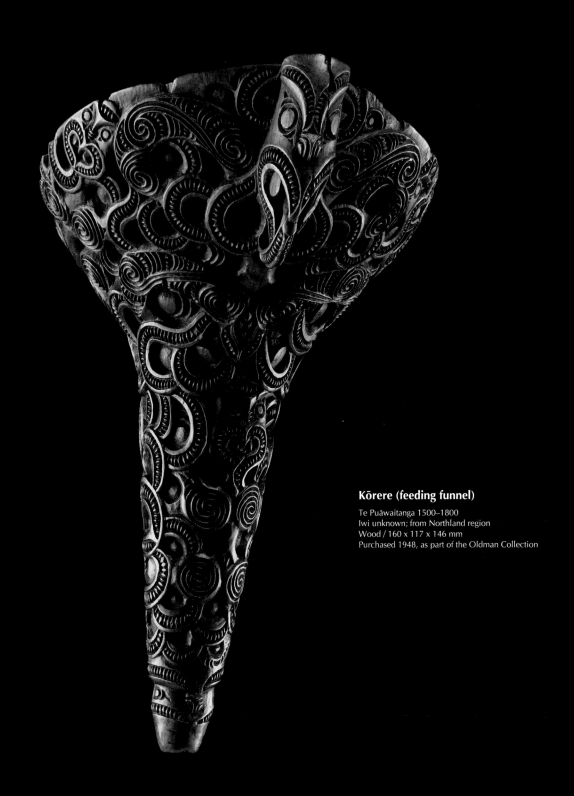

Kōrere (feeding funnel)

Te Puāwaitanga 1500–1800
Iwi unknown; from Northland region
Wood / 160 x 117 x 146 mm
Purchased 1948, as part of the Oldman Collection

The carved face

Ethnologist Augustus Hamilton commissioned the panel opposite in
1896. It illustrated faces patterned by tā moko for one of the first major
books on Māori art. The panel shows two men with full facial moko and
a woman with moko on the lips, chin and forehead. The practice of
tattooing men and women differently is still observed today. The carver,
Tene Waitere, was not a tā moko specialist. He was a tohunga whakairo
(master carver) and teacher from a central North Island tribe famous
for its carvers. This work is an example of his innovation, too. Waitere
applied a sculptural approach from Western art to customary Māori
carving, producing a more naturalistic face.

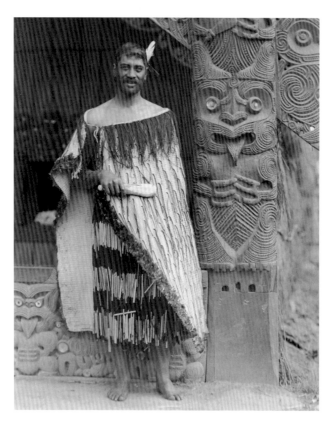

Master carver Tene Waitere, responsible for carving many meeting
houses and a wide range of unique items, including the innovative tā
moko panel opposite.

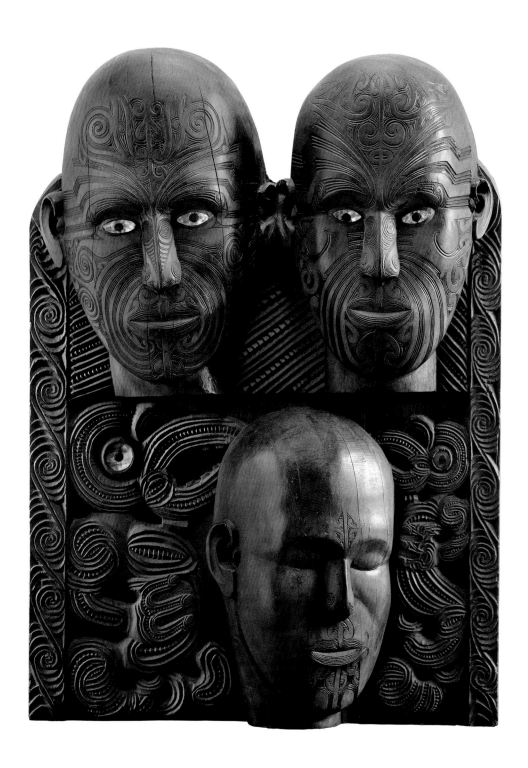

Tā moko panel

1896, Te Huringa I 1800–1900
Ngāti Tarāwhai; from Ruatō, Rotorua region
Carved by Tene Waitere
Tōtara wood, pāua shell, paint / 780 x 560 x 150 mm
Purchased 1914, as part of the Augustus Hamilton Collection

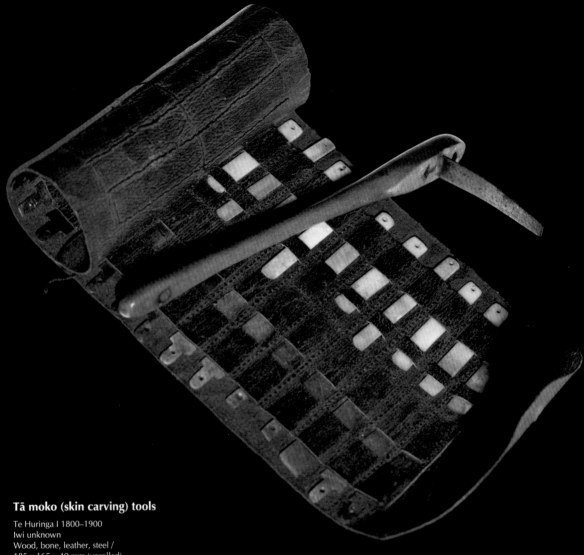

Tā moko (skin carving) tools

Te Huringa I 1800–1900
Iwi unknown
Wood, bone, leather, steel /
185 x 165 x 40 mm (unrolled)
Purchased 1958, as part of the Webster Collection

Tools for tā moko

Customary tools used for tā moko were made from wood and bone. After European contact, tā moko experts began experimenting with metal tools. The leather kit opposite contains a mixture of metal and bone chisels. The chisel blades were bound to a wooden handle. The tā moko expert would draw the design on the face with charcoal. He cut deep grooves into the skin by tapping a small flat-head chisel with a wooden mallet. Pigment was then applied to the grooves with a toothed chisel. The pigment stained the grooves dark, creating a dramatic appearance very similar to woodcarving. This process is sometimes still used in contemporary tā moko. An eyewitness account of the tattooing of high chief Iwikau Te Heuheu's face describes the chief 'being chipped on the cheek bone . . . The man spoke to me with perfect nonchalance for a quarter of an hour, although the operator continued to strike the little adzes into his flesh with a light wooden hammer the whole time, and his face was covered with blood.' [2]

Riki Manuel, tā moko artist, working on a contemporary moko, Te Papa, 2004.

A perfectly preserved face

In the late nineteenth century, chief Wiremu Te Manewha allowed a European artist, Gottfried Lindauer, to take a plaster cast of his finely carved face. This was a very unusual act. Māori of Te Manewha's generation believed that the head was the most sacred part of the body. The cast preserved Te Manewha's features perfectly and in particular his moko. He is said to have had the lines of his moko cut twice into his face, to deepen them. Te Manewha was a leader who distinguished himself in major intertribal battles in the lower North Island in the 1830s. For his descendants, this mask is a revered memorial.

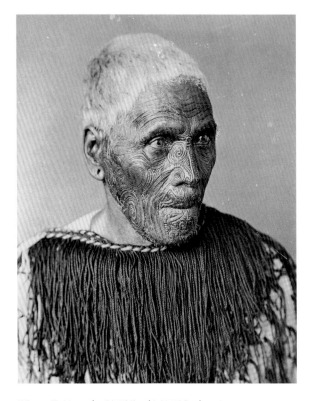

Wiremu Te Manewha (Ngāti Korokī, Ngāti Raukawa).

Life mask of Wiremu Te Manewha (Ngāti Korokī, Ngāti Raukawa)

c. 1885, Te Huringa I 1800–1900
Gottfried Lindauer and Sir Walter Buller
Plaster, paint / 230 x 160 x 130 mm

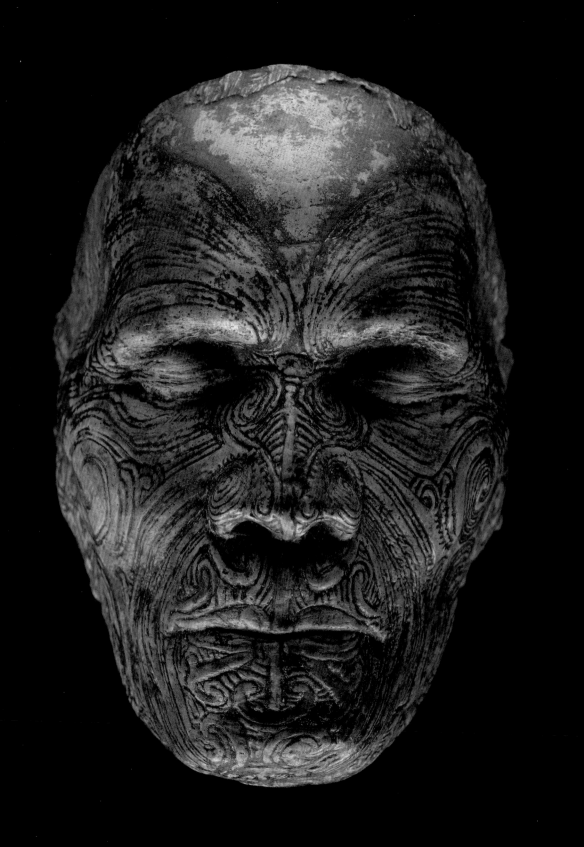

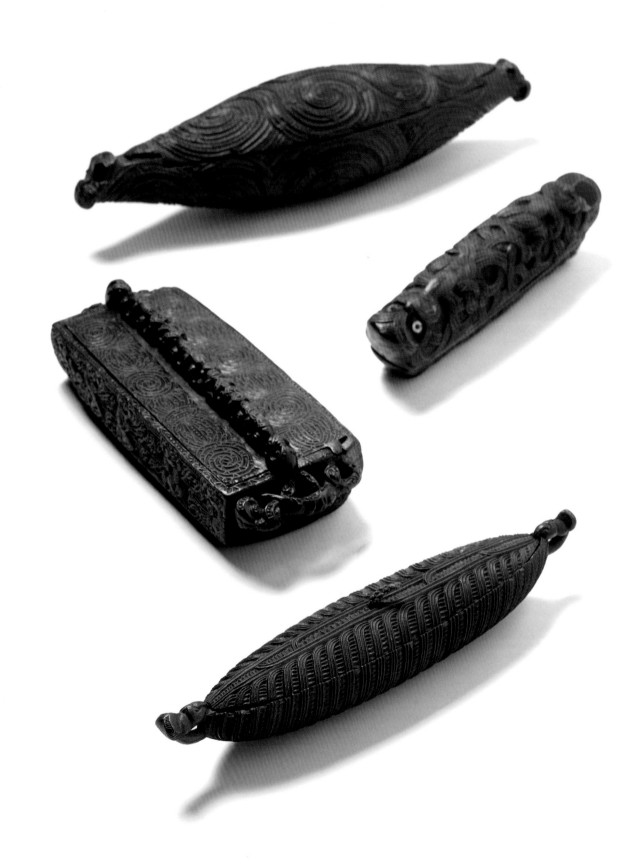

Waka huia and papa hou

Protective vessels, personal taonga

Personal taonga – items of personal significance and value – were important for Māori because of their connections to iwi, particular events or beliefs. Such items include waka huia and papa hou (treasure containers), and ceremonial objects, but also new forms not based on historic precedents. Some of these show European influences and represent adaptations to the changing times Māori found themselves in. Despite their connection to particular individuals, these taonga often convey significant stories and offer insights into ongoing traditions.

Sacred vessels

Waka huia were both functional and beautiful. They were made to store valued personal ornaments, particularly the feathers of the now extinct huia bird. The black-and-white tail feathers of the huia were hair adornments of great distinction, worn by people of high rank.

Treasure containers were hung from the rafters of a chief's house, keeping his personal adornments safe from damage and mischief. They were regarded as tapu because of their association with the chief, whose person was also regarded as tapu. They were admired by guests, and enhanced personal and tribal prestige.

Waka huia and papa hou were often elaborately carved, with intricate patterns that combined human figures and deities with symbolic spiral and scroll designs. Many had personal names. Some were also tribal treasures that might be given as gifts to recognise intertribal relationships.

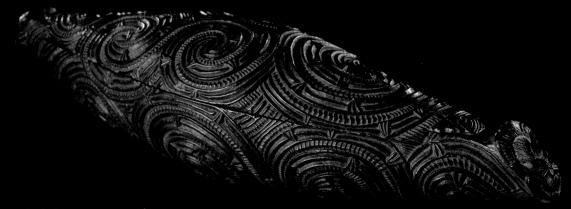

Waka huia (treasure container)

Te Puāwaitanga 1500–1800 or Te Huringa I 1800–1900
Iwi unknown
Wood, pigment / 90 x 90 x 420 mm
Purchased 2005

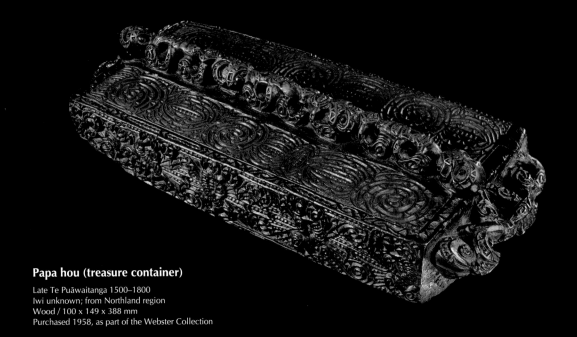

Papa hou (treasure container)

Late Te Puāwaitanga 1500–1800
Iwi unknown; from Northland region
Wood / 100 x 149 x 388 mm
Purchased 1958, as part of the Webster Collection

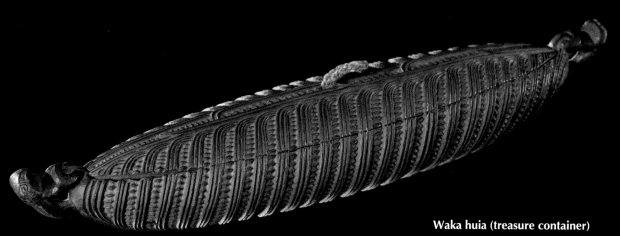

Waka huia (treasure container)

Early Te Huringa I 1800–1900
Te Āti Awa (attributed); from Taranaki region
Wood, pāua shell / 180 x 125 x 560 mm
Purchased 2005

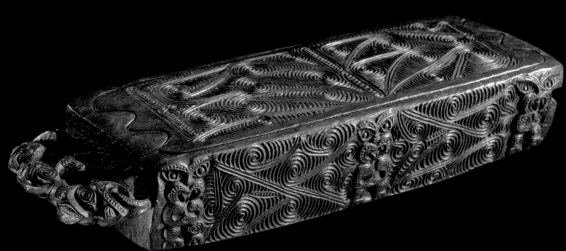

Papa hou (treasure container)

Te Huringa I 1800–1900
Iwi unknown; from Northland region
Wood / 80 x 125 x 475 mm
Purchased 2005

Rare personal treasures

Magnificent carving covers every surface of this waka huia,
including the underside, which would be revealed when
the waka huia hung from the rafters. On the lid is a carving
of a male and a female figure joined in sexual union. These
could represent either two important ancestors or the
parent gods Ranginui and Papatūānuku.

Waka huia (treasure container)

Te Huringa I 1800–1900
Rongowhakaata (attributed)
Wood / 251 x 255 x 767 mm
Purchased 1948, as part of the Oldman Collection

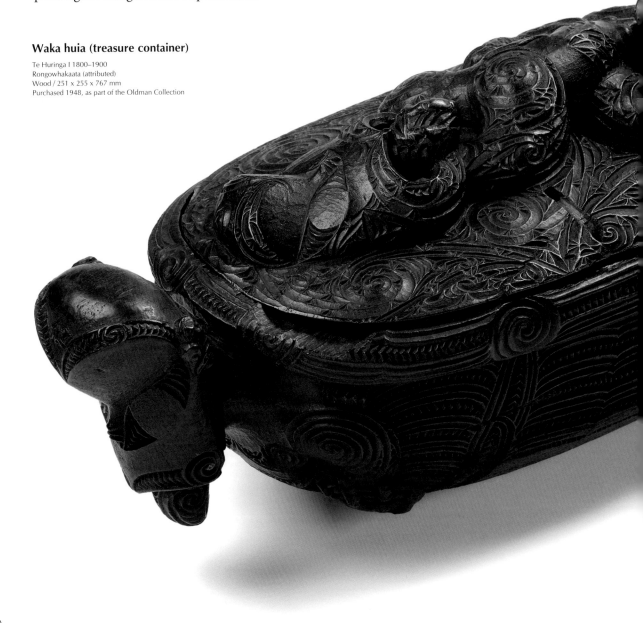

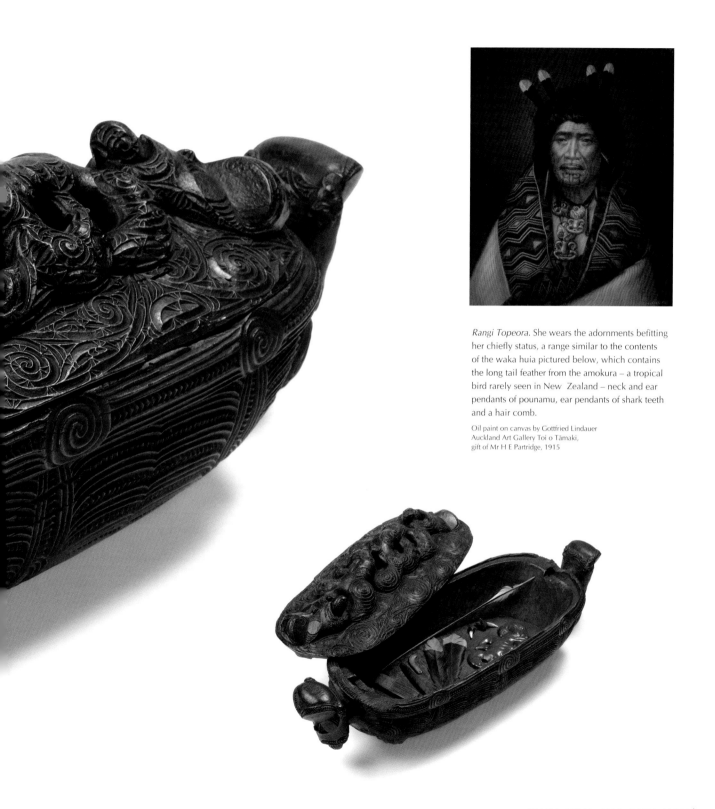

Rangi Topeora. She wears the adornments befitting her chiefly status, a range similar to the contents of the waka huia pictured below, which contains the long tail feather from the amokura – a tropical bird rarely seen in New Zealand – neck and ear pendants of pounamu, ear pendants of shark teeth and a hair comb.

Oil paint on canvas by Gottfried Lindauer
Auckland Art Gallery Toi o Tāmaki,
gift of Mr H E Partridge, 1915

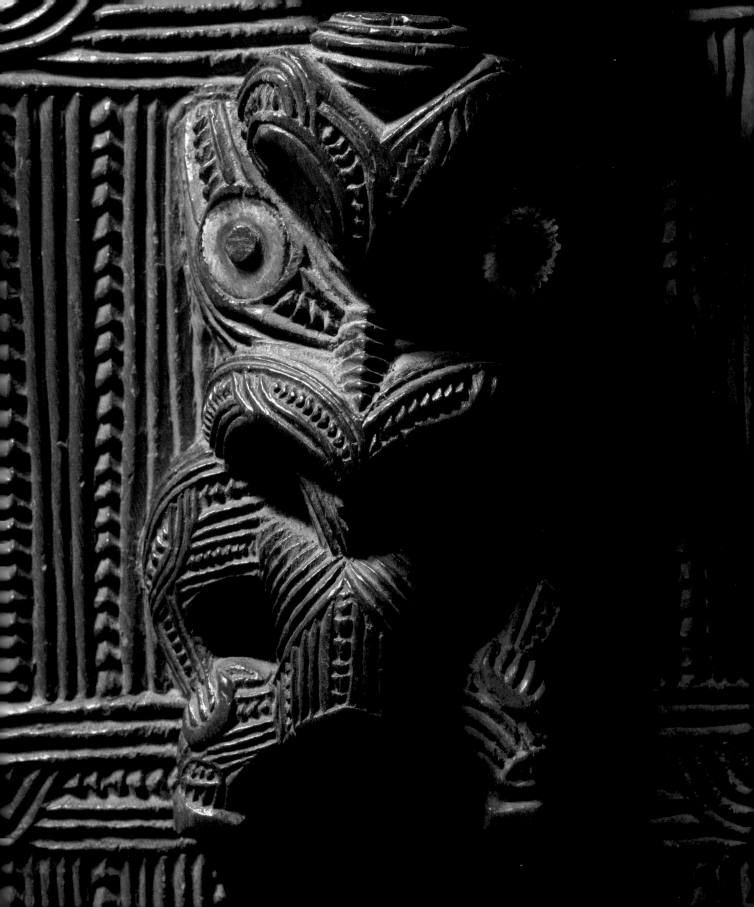

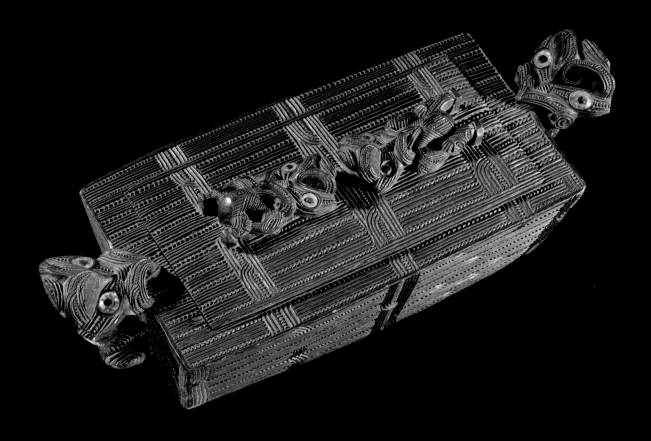

A box-like design

This treasure container with its flat, straight edges and box-like shape
looks as though it has been influenced by European design. But it is
probably a traditional form, although less common than the smoothly
rounded treasure boxes.

**Pouaka whakairo
(treasure container)**

Te Huringa I 1800–1900
Iwi unknown
Wood, pāua shell / 515 x 204 x 140 mm
Purchased 2005

Chisels for fine craftsmanship

A master carver skilfully fashioned papa hou and other fine taonga using whao (chisels). A large blade and a mallet were used to shape the object, then the fine surface pattern was carved with small hand-held chisels. Chisel blades were usually ground from pounamu and bound to wooden handles. Some blades could also be worn as pendants, with a hole bored for a cord (see page 90). They became treasured family heirlooms.

Carvers at Te Puia, the New Zealand Māori Arts and Crafts Institute, Rotorua, 1993.

Photograph by David Hamilton

Ānaha Te Rāhui (Ngāti Tarāwhai), tohunga whakairo. Te Rāhui carved the peace chalice on page 81 and the meeting house on page 38.

Whao (chisel)

Left to right:

Te Huringa I 1800–1900
Iwi unknown
Pounamu (nephrite) / 70 x 19 x 12 mm
Purchased 1997

Te Huringa I 1800–1900
Ngāti Kahungunu (attributed)
Pounamu (nephrite), wood, fibre /
150 x 20 x 20 mm
Purchased 1905, as part of the Hill
Collection

Te Huringa I 1800–1900
Iwi unknown; from Gisborne region
Pounamu (nephrite) / 81 x 14 x 9 mm
Purchased 1905, as part of the Hill
Collection

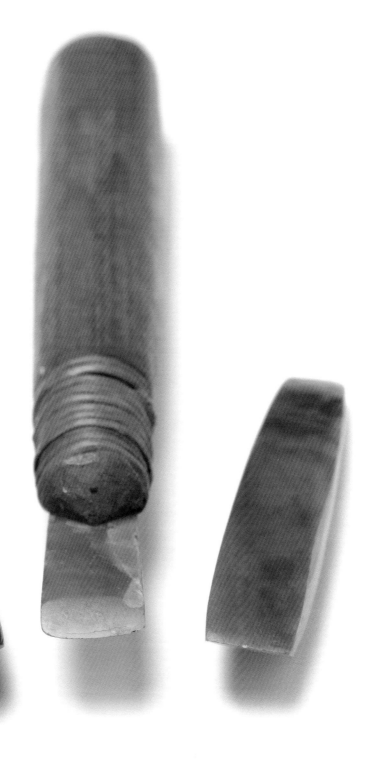

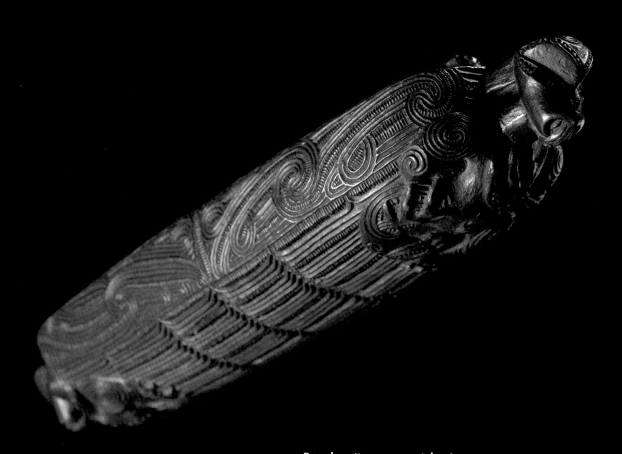

Papa hou (treasure container)

Late Te Puāwaitanga 1500–1800 or early Te Huringa I 1800–1900
Iwi unknown
Wood / 93 x 130 x 475 mm
Acquired 1921, as part of the Purvis Russell Collection

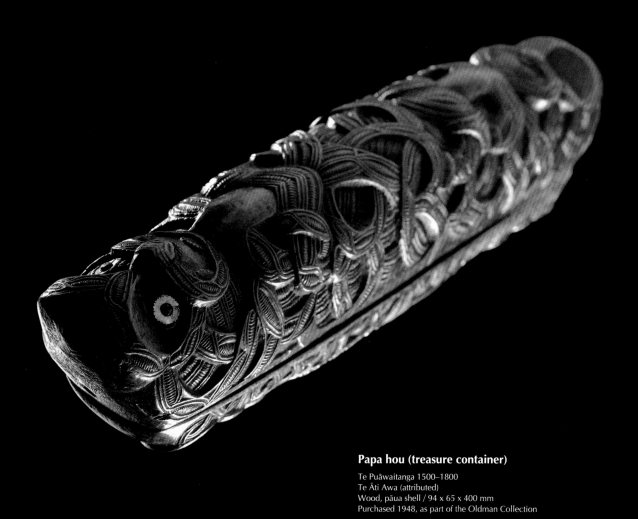

Papa hou (treasure container)

Te Puāwaitanga 1500–1800
Te Āti Awa (attributed)
Wood, pāua shell / 94 x 65 x 400 mm
Purchased 1948, as part of the Oldman Collection

Celebrating peace

An intricately carved figure with full facial moko and both male and female characteristics holds this bowl on upraised arms, as though it is a chalice or ceremonial cup. There are only two carvings like this in existence. Both were made by Ānaha Te Rāhui, one of the famous carvers of the Ngāti Tarāwhai tribe of the central North Island.

Te Rāhui gave this carving to Robert Graham, probably in appreciation of his work as a negotiator. Graham was an entrepreneur and later politician who came to New Zealand in 1842. He learned to speak Māori and understood the difficulties Māori experienced in dealing with the impacts of colonial government.

In June 1878, he intervened in a serious conflict over land in Maketū (in the Bay of Plenty) between two chiefs, Te Pōkiha Taranui (Ngāti Pikiao) and Pētera Te Pukuatua (Ngāti Whakaue). For three days and nights, he negotiated with the chiefs, eventually convincing them not to fight until he had asked the government to deal with problems and frustrations that the Native Land Court had created over their inconsistent land transactions. Later, 155 Māori gathered to give him land (which the government would later disallow) and a range of carvings in gratitude for what he had done.

Te Rāhui incorporated many important stylistic features into this unique gift, which paid respect to Graham for the peace he helped restore between tribes. The male moko elements and strong female attributes suggest a potential for wellbeing – a mutually positive future that would issue from the relationship forged between such important chiefs, Graham and his family. Over time Robert Graham's descendants began to refer to the carving as the 'peace chalice' or 'peace bowl'.

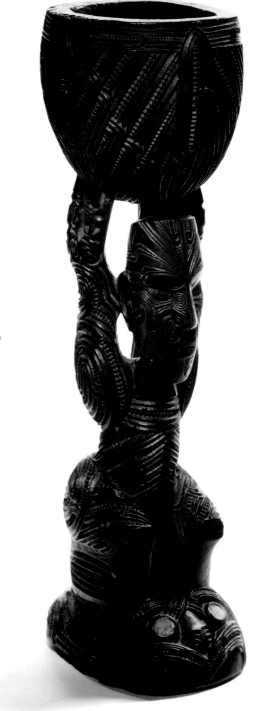

Peace Chalice

Te Huringa I 1800–1900
Ngāti Tarāwhai; from Ruatō, Rotorua region
Carved by Ānaha Te Rāhui
Tōtara wood / 488 x 184 x 138 mm
Purchased 2001 with New Zealand Lottery
Grants Board funds

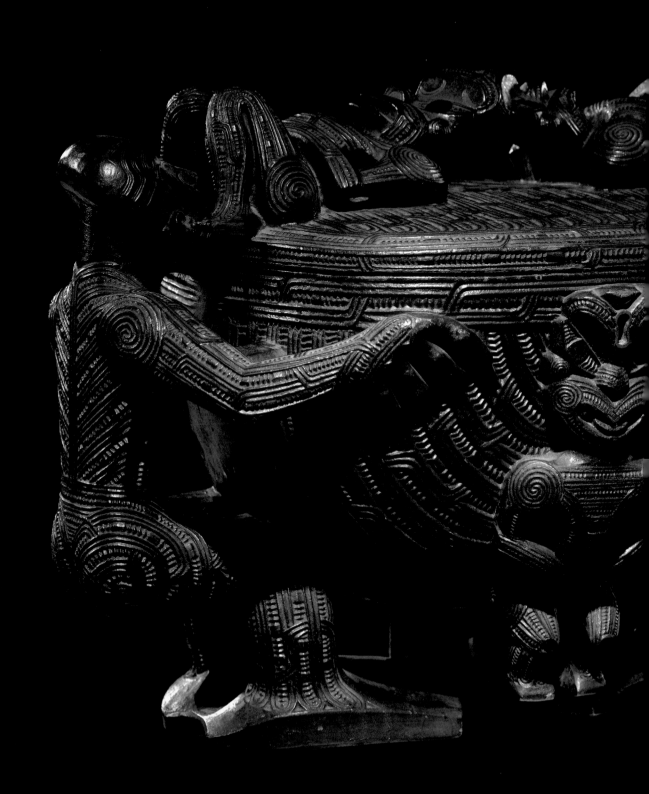

New designs

A bowl-shaped container with a lid was not a traditional form for Māori. This kumete (food bowl) was an innovative design, believed to have been made by master carver Patoromu Tamatea. He was influenced by the demands of a new market: Europeans living in New Zealand in the mid eighteenth century. As well as presentation bowls, Tamatea made boxes, walking sticks, figures and tobacco pipes for the growing European tourist trade. This kumete was presented to the son of the great warrior chief Te Rauparaha.

Kumete (food bowl)

Te Huringa I 1800–1900
Ngāti Pikiao from Lake Rotoiti, Rotorua region
Carved by Patoromu Tamatea
Wood / 450 x 330 x 350 mm
Gift of Mrs Chorlton, 1961

Ceremonial fragment

Little information about this carving remains. The whakapakoko (carved figure) is a very rare fragment of a ritual item. It is perhaps a rākau atua (ceremonial rod), used by religious leaders as a medium for communicating with the gods and treated with the utmost respect and reverence. Or it may be a ceremonial fragment of a taurapa, where a small carved ancestor looked back across the warriors in a war canoe.

Whatever its ritual use, the intricate tā moko and fine carving on the figure emphasised that the religious leader or warrior had entered a sacred realm. This ceremonial figure is a superb example of form, style and facial moko, with distinctive and refined haehae (grooves) and pākati (raised notches). It represents an ancestral figure of great age and esteem.

Whakapakoko (carved figure)

Te Puāwaitanga 1500–1800
Iwi unknown
Wood / 283 x 70 x 48 mm
Purchased 1997

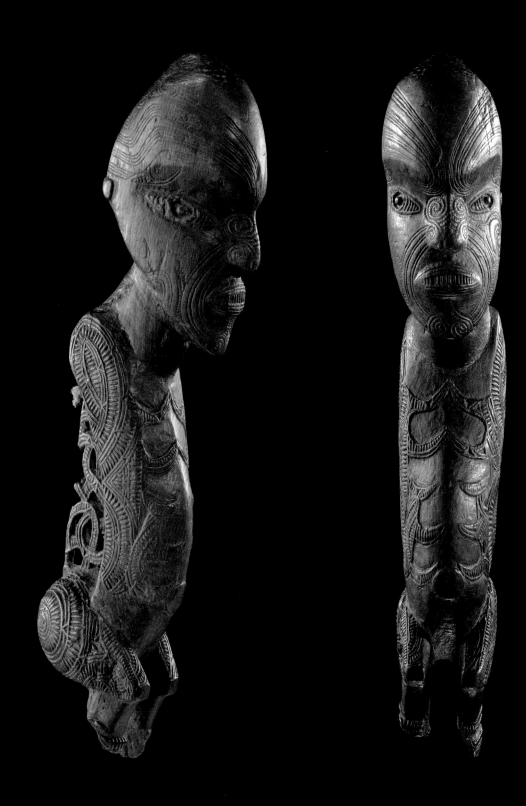

Carved puppets

Spiritual leaders used karetao (puppets) in rituals, to dramatise the telling of stories and to accompany songs. The head, body and legs of the karetao are usually carved from a single piece of wood. Cords move the arms and legs, making the karetao perform movements like those of the haka. The karetao opposite have finely carved tā moko on their faces and bodies, which indicates they had a ritual use. The smaller karetao here has an unusual mixture of Māori and European features. The carvings on the face and chest are Māori in design, but they are combined with a European cap and heeled boots, and a military-style moustache. It is possible this karetao was used to ridicule or influence the militia in some way during the land war campaigns.

Karetao (puppet)

Left to right:

Te Huringa I 1800–1900
Iwi unknown; from Thames, Coromandel region
Ngāti Maru
Wood / 400 x 290 x 50 mm
Purchased 1975

Te Huringa I 1800–1900
Iwi unknown
Wood, fibre / 530 x 100 x 73 mm
Purchased 1948, as part of the Oldman Collection

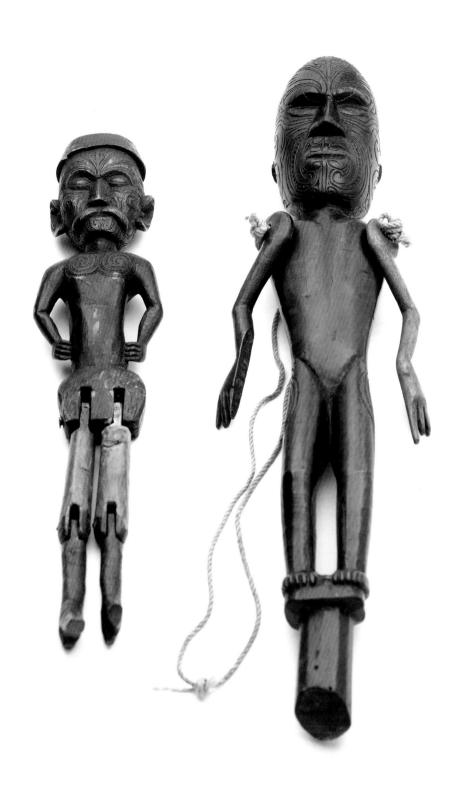

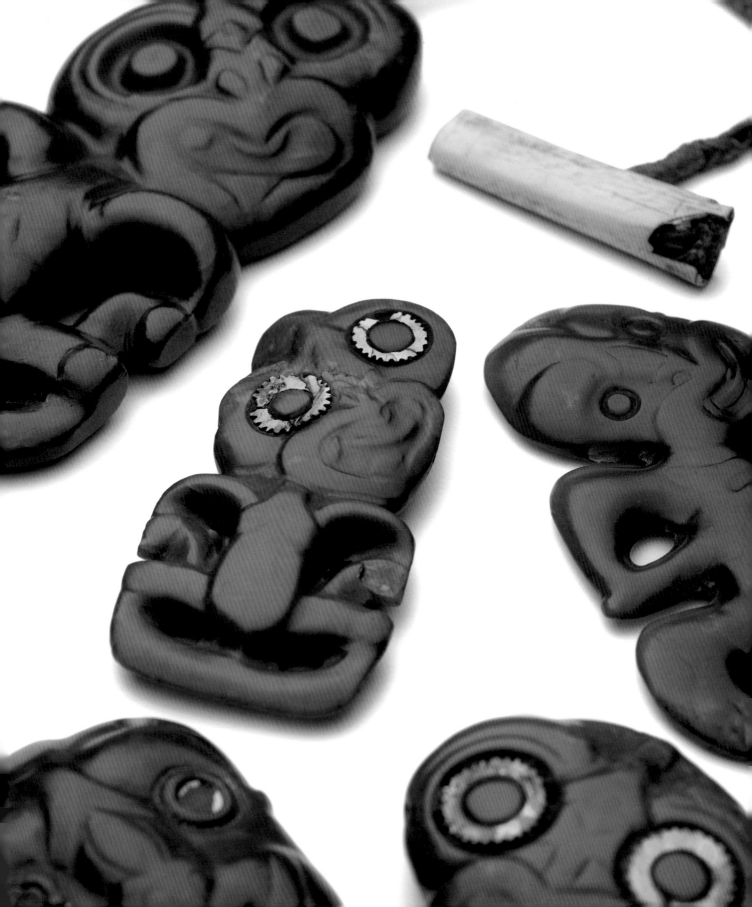

Taonga whakarākai

Items of adornment

Taonga whakarākai are personal taonga but also items of adornment. In former times, Māori wore a wide range of taonga whakarākai to show leadership, status and whakapapa. These adornments were made of wood, bone and various types of stone including pounamu. Most ornaments were worn on the head or near it: the term 'hei kakī' describes pendants or necklaces hung around the neck ('hei' means 'to suspend'). Māori also wore valued items hung from the ear, and dressed their hair with finely carved combs of whalebone or wood. These ornaments would be treated with reverence by their association with the head, the most tapu part of the body. As a chief was particularly tapu, the ornaments worn on or near the chief's head – feathers, combs, and ear and neck pendants – were kept out of reach in special containers like waka huia and papa hou.

Pendants and necklaces

Of the various neck pendants worn by Māori, the most distinctive takes the form of a highly stylised human figure called the tiki. Hei tiki are usually made of pounamu and are among the most valued of all Māori ornaments. The tiki form is found in the woodcarving of almost all Pacific cultures, but only Māori made it into a pendant to wear around the neck. Hei tiki probably became common from the fifteenth century. In the eighteenth and nineteenth centuries they were the most popular and prized of all pendants.

The meaning of the tiki is not clear. It may represent Hine-te-iwaiwa, a celebrated ancestor who symbolises Māori womanhood, including the ability to bear children. It may also represent Tiki, the first man.

Sometimes, after death, hei tiki were buried with the owner. After one year the body was exhumed, the bones prepared for final burial and the hei tiki reclaimed. These hei were especially tapu because of their intimate association with death.

Other forms of pendant include the pekapeka (bat) and the marakihau (a sea creature), based on animal forms, and the hei matau, a stylised fish-hook pendant. Many styles of pendant reflect the importance of the sea. Shark teeth set in silver or gold as necklaces or ear pendants were fashionable in the later nineteenth and early twentieth centuries. Shark-tooth shapes were also created from pounamu or serpentinite and made into necklaces. For Māori, the shark is an important symbol of bravery and strength. It exemplifies power and endurance as a leader, or a fighter, unflinching in combat.

Sometimes adzes or chisels were also used as pendants. Although a woodcarving tool, the toki pictured here has a suspension hole at the top suggesting it could have been worn and treasured as a pendant.

Toki (adze head)

Te Puāwaitanga 1500–1800
Iwi unknown
Pounamu (nephrite) / 314 x 63 x 22 mm
Gift of Alexander Turnbull, 1913

Gifting and ownership

Prized personal possessions like hei tiki were often given spontaneously at important public events. The exchange of gifts is a widespread custom in the Pacific, acknowledging the significance of an event and honouring both the giver and the recipient. Personal adornments were also offered as peacemaking tokens between peoples, both Māori and non-Māori.

Often adornments were given ancestral or personal names. They were charged with the tapu and mana of revered ancestors, and they would acquire the history and vitality of each succeeding generation that wore and looked after them.

Wearers do not possess these taonga as their own property. They hold these treasures in trust for future generations, and are responsible for preserving the knowledge of stories or events associated with them. Personal adornments become family treasures worn by descendants today as marks of respect for the continued guidance of ancestors in contemporary life. Glenis Philip-Barbara (pictured here) has responsibility in her lifetime as the eldest granddaughter to care for the family taonga she is wearing. Whānau members come to collect the hei tiki to wear for special occasions, events or performances, and they return the hei afterwards to Glenis for safekeeping. As Glenis says, 'It will pass from me to my eldest granddaughter when I feel that she is responsible enough to care for this taonga on behalf of the whānau.'

Glenis Hiria Philip-Barbara (Ngāti Rangi, Te Whānau a-Tapuhi, Te Whānau-a Hunaara) with a family hei tiki passed into her guardianship from her grandmother, Hiria Wanoa (née Aupouri).

Photograph by Walton Walker

Hei tiki (neck pendant in human form)

Te Puāwaitanga 1500–1800
Iwi unknown
Pounamu (nephrite), pāua shell,
pigment / 123 x 78 x 19 mm
Purchased 1972

Hei tiki (neck pendant in human form)

Te Puāwaitanga 1500–1800
Iwi unknown
Pounamu (nephrite) /
137 x 86 x 19 mm
Purchased 1948, as part of
the Oldman Collection

The signature of the carver

The peaked head of this hei tiki is believed to represent the sacred mountain Taranaki, a cone-shaped volcano in the west of the North Island. The shape of the head is like a signature, showing that the carver was from the Taranaki region. The eyes are made from the multicoloured shell of the pāua. They are set in a natural resin coloured with red ochre. After contact with Europeans, Māori adopted red wax, used for sealing letters, to fix the eyes of hei tiki.

Hei tiki (neck pendant in human form)

Te Puāwaitanga 1500–1800 or
Te Huringa I 1800–1900
Ngāti Kura, Ngāti Mutunga, Te Āti Awa
(attributed)
Pounamu (nephrite), pāua shell,
pigment / 101 x 50 x 13 mm
Purchased 2004

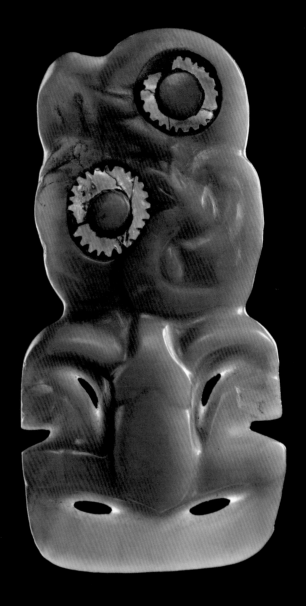

**Hei tiki (neck pendant
in human form)**

Te Puāwaitanga 1500–1800
Iwi unknown
Pounamu (nephrite) /
121 x 73 x 9 mm
Purchased 1975

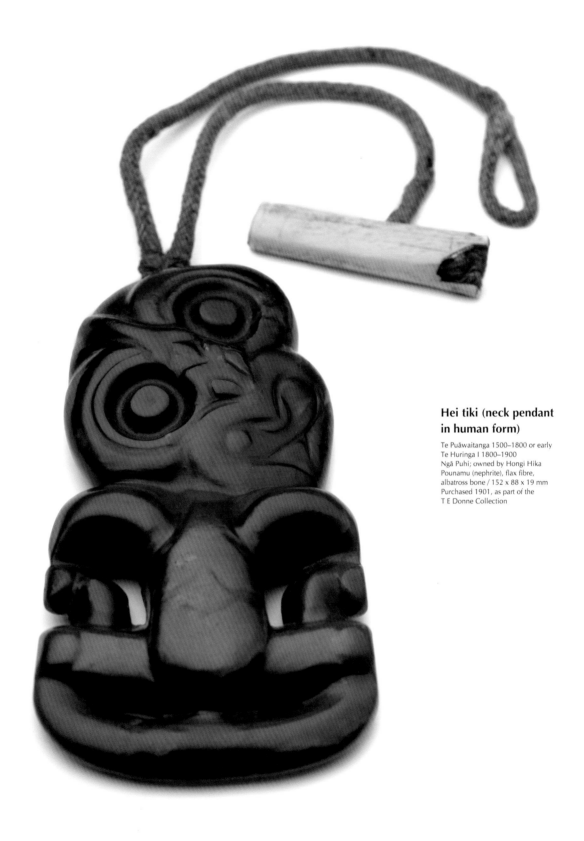

Hei tiki (neck pendant in human form)

Te Puāwaitanga 1500–1800 or early
Te Huringa I 1800–1900
Ngā Puhi; owned by Hongi Hika
Pounamu (nephrite), flax fibre,
albatross bone / 152 x 88 x 19 mm
Purchased 1901, as part of the
T E Donne Collection

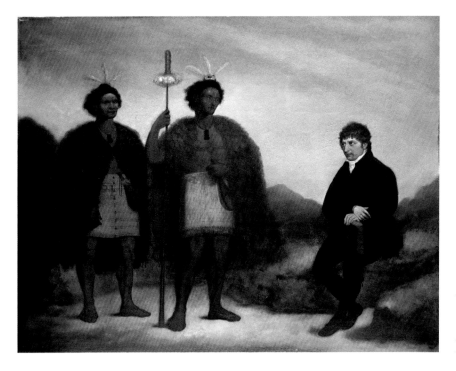

Waikato (Ngā Puhi) (left), Hongi
Hika (Ngā Puhi) and Reverend
Thomas Kendall of the Church
Missionary Society, painted in
London during their 1820 visit.

Oil painting by James Barry
Alexander Turnbull Library G-618

A warrior's tiki

Hongi Hika was a great warrior and leader of the Ngā Puhi tribe in the
early nineteenth century. The hei tiki opposite belonged to him. It is
made from high-quality pounamu, and is the work of a master carver.
In 1820, Hongi Hika travelled to England with the Christian missionary
Thomas Kendall and took this hei tiki with him as a presentation gift. In
England, Hongi Hika assisted with the compilation of a Māori dictionary.
He also acquired firearms, which his tribe later used to devastating effect
in intertribal warfare.

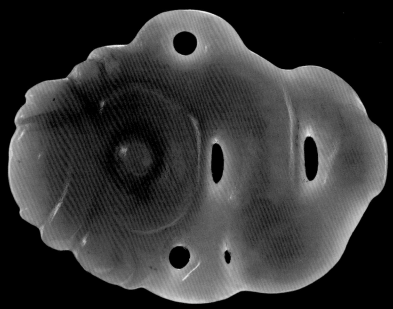

Marakihau (sea creature neck pendant)

Te Puāwaitanga 1500–1800 or early
Te Huringa I 1800–1900
Iwi unknown
Pounamu (nephrite) / 41 x 55 x 7 mm
Gift of Alexander Turnbull, 1913

Pekapeka (neck pendant)

Te Puāwaitanga 1500–1800 or
Te Huringa I 1800–1900
Iwi unknown
Pounamu (nephrite) / 35 x 55 x 6 mm
Purchased 1948, as part of the
Oldman Collection

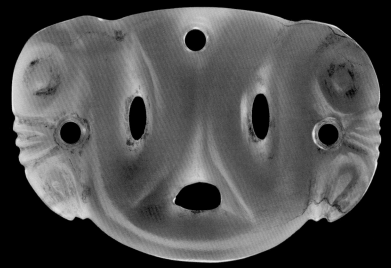

Creatures from sea and land

The marakihau is a supernatural being, depicted as half human and half fish. According to tribal narratives, the marakihau could upturn canoes and swallow people whole. Marakihau were often represented in meeting houses with a fish-like tail and an elongated tongue. They are found on pendants and in woodcarvings from the eastern Bay of Plenty. The human body and coiled fish tail of a marakihau are represented on the pendant opposite.

Often carved from pounamu, the pekapeka is a form of neck pendant that takes its name from the native bat. The features may be difficult to discern, but the pekapeka has a head, eye and body, and is like a small creature curled up on itself.

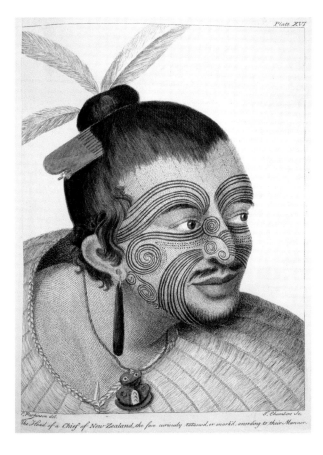

A tattooed chief wearing personal adornments including a heru, feathers and pounamu.

Plate 16 in *A journal of a voyage to the South Seas* by Sydney Parkinson, hand-coloured engraving by T Chambers
Alexander Turnbull Library PUBL-0037-16

Symbolic fish-hook

Wearing hei matau today indicates the strong connection people have with Tangaroa, and with all things of the sea. The hei matau is generally shaped as a stylised fish-hook, made of pounamu and worn at the breast, lower down than the hei tiki. The form recalls the action of the cultural hero Māui, a demigod and a trickster who fished up the North Island from the realm of Tangaroa with a hook made from the jawbone of an ancestress. The North Island is still known to Māori as Te Ika-a-Māui (the fish of Māui). When Māui hauled up his great catch, he was so delighted he tossed his hook into the heavens, where it caught and hung, outlined with bright stars. The fish-hook of Māui is also known as the constellation Scorpius.

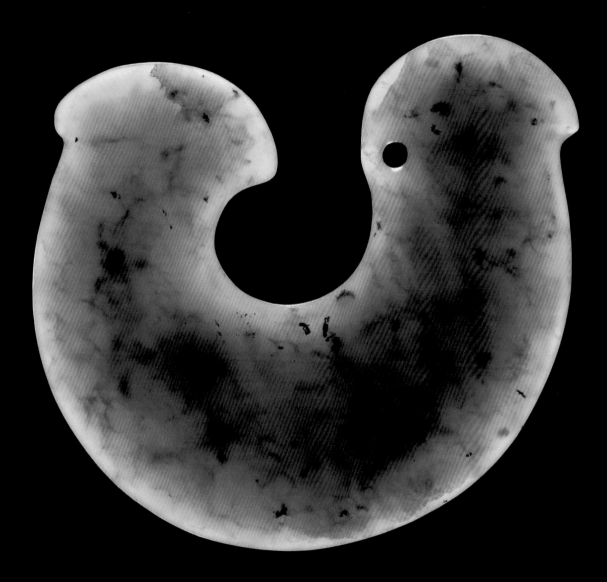

**Hei matau
(fish-hook pendant)**

Te Puāwaitanga 1500–1800
Iwi unknown
Pounamu (nephrite) / 90 x 76 x 9 mm
Purchased 1991

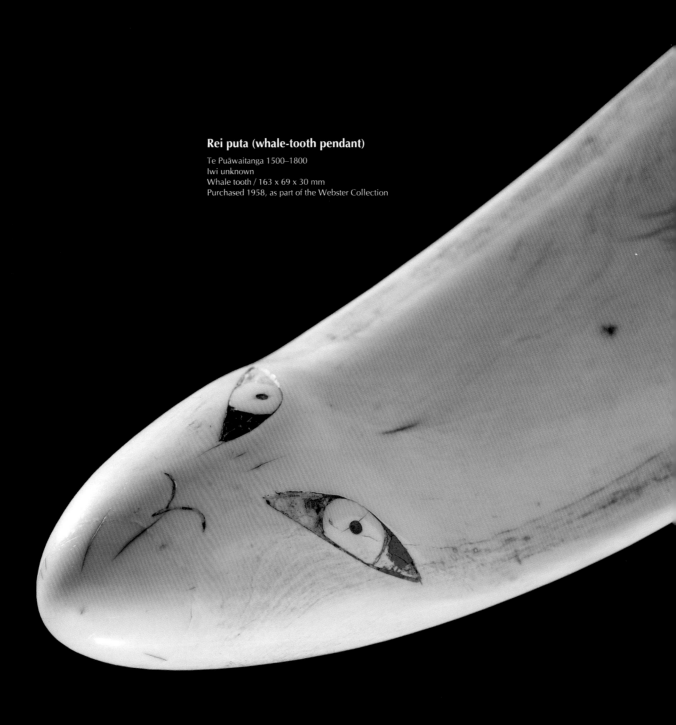

Rei puta (whale-tooth pendant)

Te Puāwaitanga 1500–1800
Iwi unknown
Whale tooth / 163 x 69 x 30 mm
Purchased 1958, as part of the Webster Collection

Rare whale teeth

Throughout the Pacific, pendants made from whale teeth are a prestigious form of personal adornment. Some rei puta (whale-tooth pendants), such as this one, have a face engraved on the tip. Māori did not hunt sperm whales, so their only sources of whalebone or teeth were beached whales. For this reason rei puta are very rare.

Head of New Zealand Warrior, c. 1769

Engraving by Jean-Baptiste Bénard, after an original drawing by Sydney Parkinson

Ear pendants

Pendants were worn from the ear as
well as around the neck. They often
had personal names and long tribal
histories. Many were given to European
leaders and officials as a mark of
enduring friendship. Kuru are long and
straight. Kapeu are extended drop-
pendants with a curved end. Scholars
believe that the kapeu may have been
used by breastfeeding mothers. The
mother would draw the pendant
down the breast to help massage and
express milk for her nursing child.
Contemporary mothers have been
known to use pounamu for teething
babies to work their gums on.

Kuru (ear pendant)

Te Puāwaitanga 1500–1800
Iwi unknown
Bowerite / 96 x 11 x 8 mm
Purchased 1989

Kapeu (ear pendant)

Te Puāwaitanga 1500–1800
Iwi unknown
Pounamu (nephrite) / 120 x 10 x 10 mm
Purchased 1948, as part of the Oldman Collection

Mako (imitation shark-tooth ear pendant)

Te Puāwaitanga 1500–1800 or early Te Huringa I 1800–1900
Iwi unknown
Serpentinite / 43 x 16 x 13 mm
Purchased 1958, as part of the Webster Collection

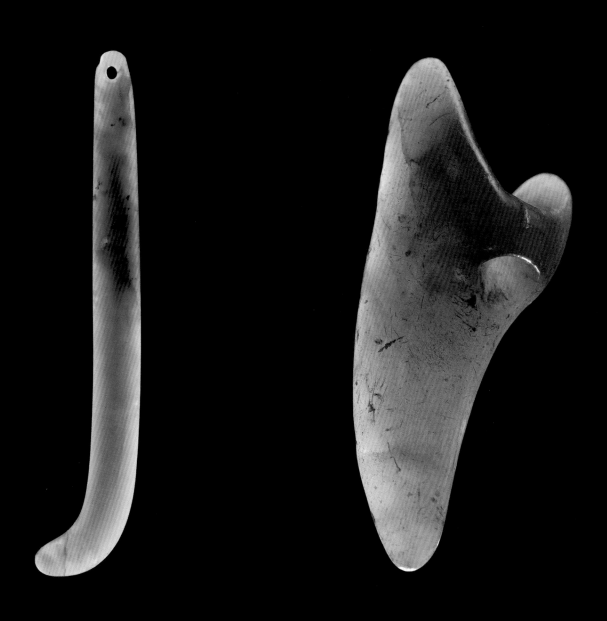

Aristocratic combs

European visitors to New Zealand in the eighteenth century would have seen men wearing finely carved heru (ornamental combs). Long hair was high fashion for chiefly Māori men at that time. The hair was oiled, braided, coiled on the head in a topknot and embellished with bird feathers and heru. Heru were an indication of status and authority. Like any personal objects associated with the sacred head area, they were carefully kept away from any casual handling.

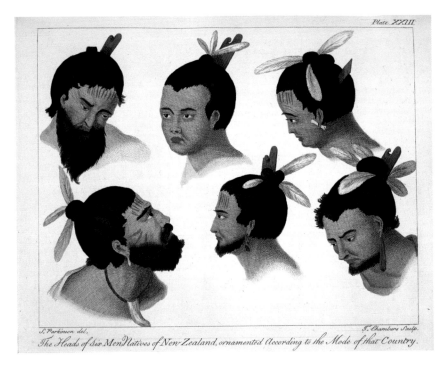

Māori men with topknots, wearing wooden combs and feathers.

Plate 23 in *A journal of a voyage to the South Seas* by Sydney Parkinson, hand-coloured engraving by T Chambers
Alexander Turnbull Library PUBL-0037-23

Heru (ornamental comb)

Clockwise from top:

Te Puāwaitanga 1500–1800
Iwi unknown
Whalebone, pāua shell / 294 x 105 x 4 mm
Purchased 1948, as part of the Oldman Collection

Te Puāwaitanga 1500–1800
Iwi unknown
Wood, pāua shell / 102 x 55 x 6 mm
Gift of the Imperial Institute, London, 1955

Te Puāwaitanga 1500–1800
Iwi unknown
Wood, flax fibre / 92 x 33 x 6 mm
Gift of S Lyon, 1867

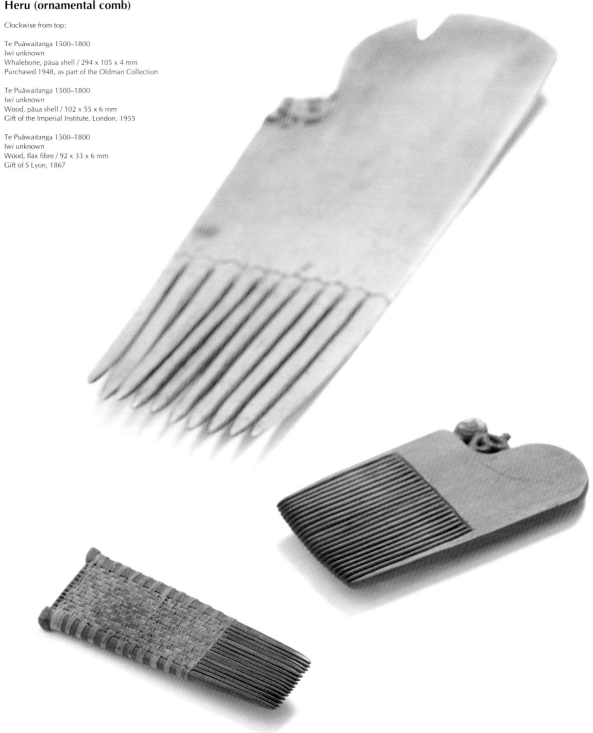

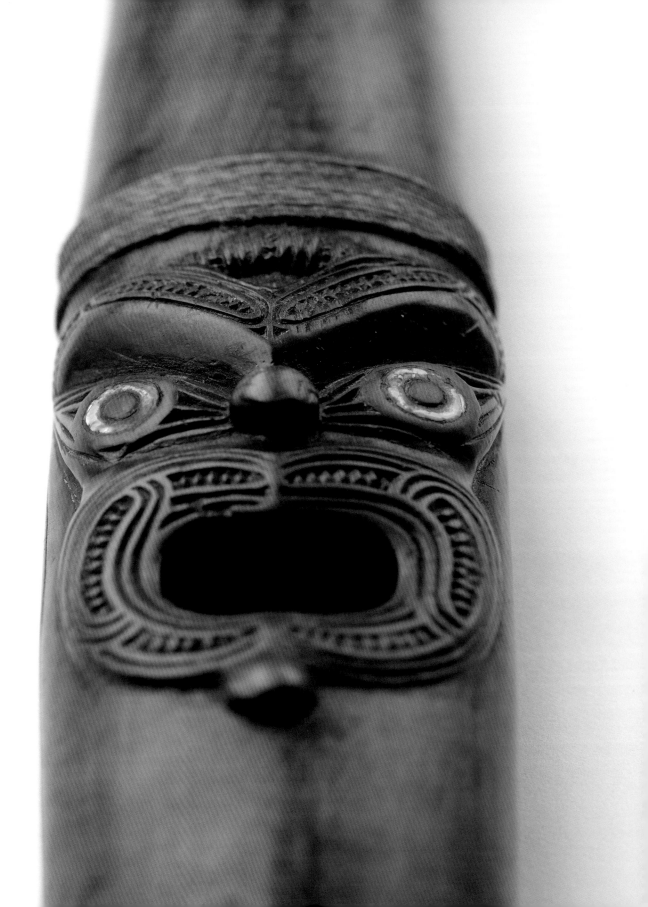

Taonga pūoro

Music of the gods

It was in the night that the gods sang the world into existence.
 'Te Hekenga-ā-rangi' [3]

Traditional Māori music has its own creation story. From Ranginui came melody, while from the heartbeat of Papatūānuku came rhythm. From their descendants came taonga pūoro (musical instruments), which join rhythm and melody. Flutes, trumpets, percussion instruments and spinning blades capture the sounds of the natural environment – of birds, of insects and of the wind. The fine crafting of these instruments expressed both respect for the sounds and effects produced through them, and esteem for the sources of musical inspiration – the gods.

Through the playing of instruments and singing, Māori express moods and emotions fit for many occasions. There are songs for mourning the departed, for the birth of a child, for insulting an enemy, for recalling genealogy, for fishing – for all aspects of life from routine welcomes on to marae to ceremonial occasions. Of course, not all songs were accompanied by musical instruments. During performances of waiata ringaringa (songs accompanied by hand movements that tell a story), many songs were given rhythm by the stamping of feet in dance or haka, the striking of hands against skin, the audible clacking and swirling of dancers' garments, and the soft padded beat of the poi (balls on cord).

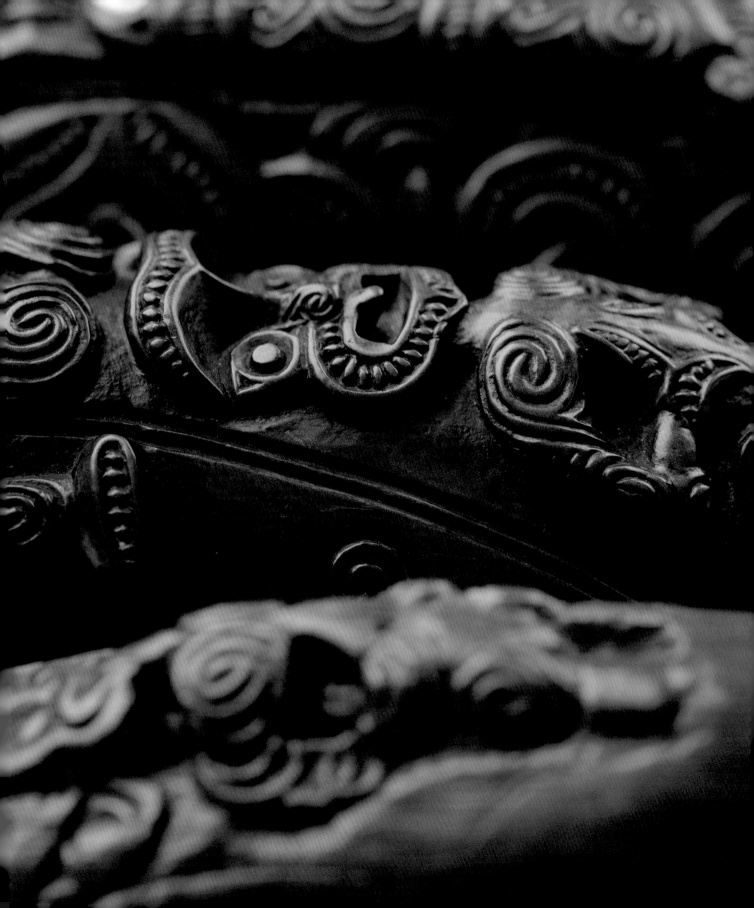

Traditional flutes

Kōauau were heard in most Māori communities into the early twentieth century, and they are still the most common instruments. They usually have three finger-holes and are often made of bone. There are also kōauau made of wood, which have a more mellow sound, and stone kōauau with clear ringing tones. They can be played by blowing through the mouth or the nose.

Nguru have four finger-holes and are shaped with one end tapering upward. They make a fuller sound than kōauau. They are mostly played with the mouth, although sometimes they are blown with the nose. Nguru are skilfully fashioned from whale ivory, stone, wood, clay and gourd stems.

Āporo of Gisborne, playing the flute, 1923.

Photograph by James McDonald

This photograph of an unknown man shows a flute being played by blowing through the nose, 1920.

Photograph by James McDonald

Kōauau (flute)

Te Puāwaitanga 1500–1800 or early Te Huringa I 1800–1900
Ngā Puhi
Wood, pāua shell / 197 x 32 x 35 mm
Purchased 1948, as part of the Oldman Collection

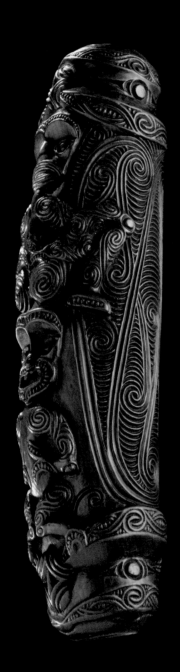
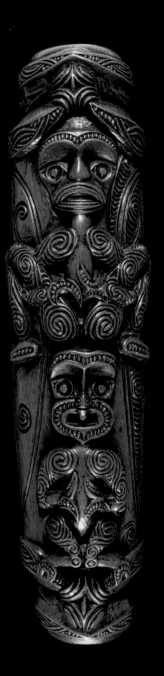

Nguru (flute)

Te Puāwaitanga 1500–1800 or early Te Huringa I 1800–1900
Iwi unknown
Wood, pāua shell, fibre / 143 x 55 x 50 mm
Purchased 1948, as part of the Oldman Collection

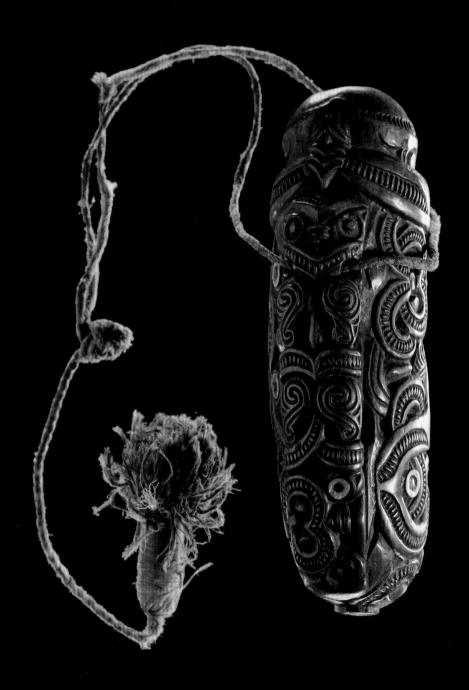

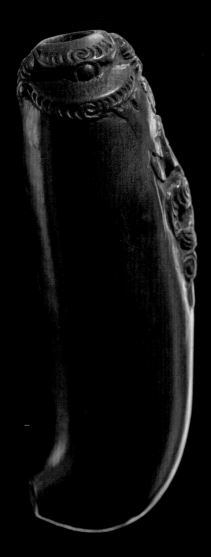

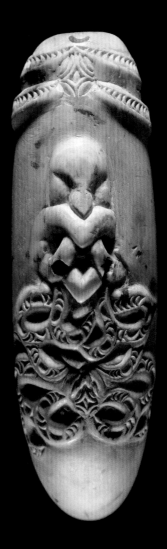

Nguru (flute)

Te Puāwaitanga 1500–1800 or early
Te Huringa 1 1800–1900
Iwi unknown
Wood, pāua shell / 155 x 52 x 45 mm
Purchased 1948, as part of the
Oldman Collection

Nguru (flute)

Late Te Puāwaitanga 1500–1800 or early
Te Huringa I 1800–1900
Iwi unknown; from Northland region
Whale tooth / 135 x 50 x 41 mm
Purchased 2002

Traditional instruments revived

With a renewal of interest in taonga pūoro there is now a growing
number of both makers and players, and these instruments are taking a
new role in the development of contemporary music. The group Hau
Manu (Breath of Birds), which grew under the guidance of the late Dr
Hirini Melbourne in the early twentieth century, have contributed much to
what is now understood about pūoro. Melbourne, a well-known composer
and musican, worked with world-renowned musician Richard Nunns,
and Brian Flintoff, a skilled craftsman and carver of bone and wood. They
reconstructed and played pūoro based on early examples in museums,
and gathered information from oral and written sources. By sharing this
information through wānanga and workshops, they breathed life back into
these ancestral treasures.

Members of Hau Manu (from left: Richard Nunns, Horomana Horo, Warren Warbrick, James Webster)
playing taonga pūoro at a museum workshop, 2006.

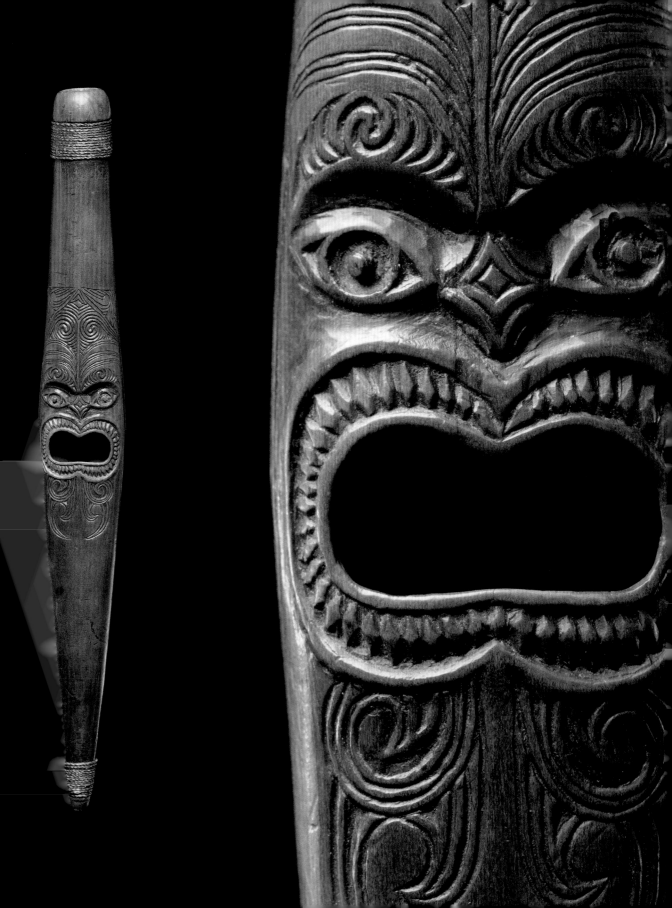

A flute with two voices

The pūtōrino (bugle flute) is an instrument unique to Māori. It has two distinct voices. The male voice sounds when the instrument is played like a bugle. The flute-like female voice is heard when the pūtōrino is side-blown. Other effects can be produced to accompany both traditional singing and rituals observed by tohunga (priests). These sounds can stir a wide range of emotions in the listener. The pūtōrino is made by splitting a piece of wood into two pieces, hollowing them, and binding them together again. The instrument's shape is like the cocoon of the small native moth that embodies Hine Raukatauri, deity of flutes, whose voice is pure, high and attractive.

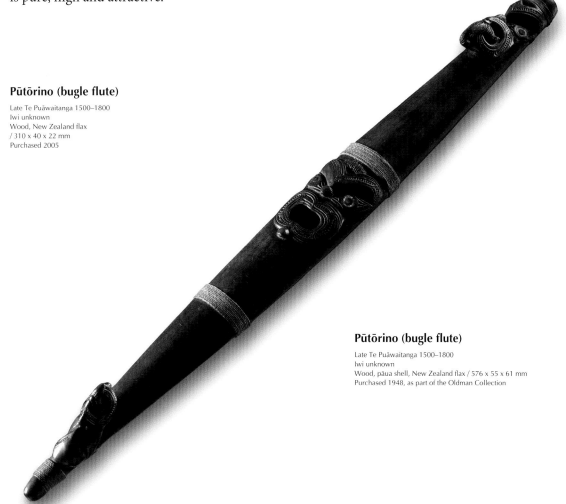

Pūtōrino (bugle flute)

Late Te Puāwaitanga 1500–1800
Iwi unknown
Wood, New Zealand flax
/ 310 x 40 x 22 mm
Purchased 2005

Pūtōrino (bugle flute)

Late Te Puāwaitanga 1500–1800
Iwi unknown
Wood, pāua shell, New Zealand flax / 576 x 55 x 61 mm
Purchased 1948, as part of the Oldman Collection

Pūtātara (shell trumpet), named
Te Umu Kohukohu

Te Puāwaitanga 1500–1800
Ngāi Tūhoe
Conch shell, wood, fibre / 110 x 230 x 110 mm
Purchased 1958, as part of the Webster Collection

Pūkāea (war trumpet)

Te Puāwaitanga 1500–1800 or
Te Huringa I 1800–1900
Iwi unknown
Wood, fibre / 500 x 89 x 88 mm
Purchased 1958, as part of the
Webster Collection

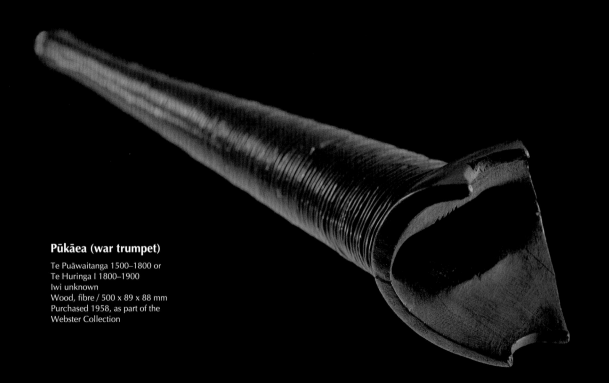

Trumpets of wood and shell

In former times, the pūkāea was known as a war trumpet, used to signal that a war party was approaching. Today, with the revitalisation of pūoro, the pūkāea welcomes people and announces events on marae around the country. The pūtātara (shell trumpet) is made from a conch shell bound to a wooden mouthpiece. It can be played melodically, but its booming sound is generally used as a signal.

The historic pūtātara opposite was owned by a chiefly family for six generations. It is made from a particularly large conch shell that would rarely be found in New Zealand. Conch shells washed up would normally be of a smaller variety. Its last use was in a battle in about 1867.

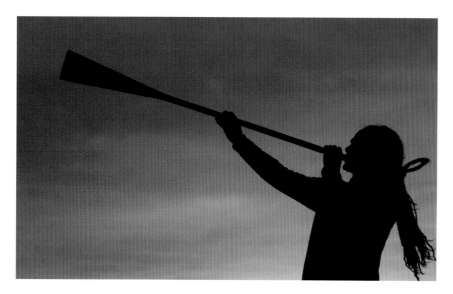

Shane James plays a pūkāea which he made from tōtara wood. The pūkāea is named Te Hokinga Mai to mark the return of ancestral remains from Canada.

Poi

Poi are twirled and beaten against the hand or body. They provide a rhythmic accompaniment to singing and dance movements. Poi are used today to entertain, but they still play an important part in cultural performance and the maintenance of customs. Poi tāniko (woven balls) are very rare. Generally they were made of raupō leaves filled with the down of the raupō flower and swung on muka handles. Today they are mostly made from synthetic materials.

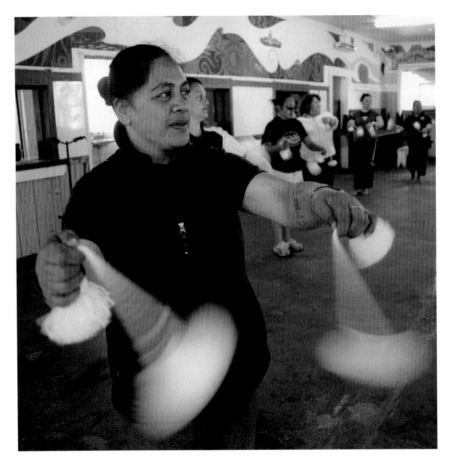

Practising poi at Te Kiritahi meeting house on the Whanganui River, 2006.

Photograph by James Heremaia

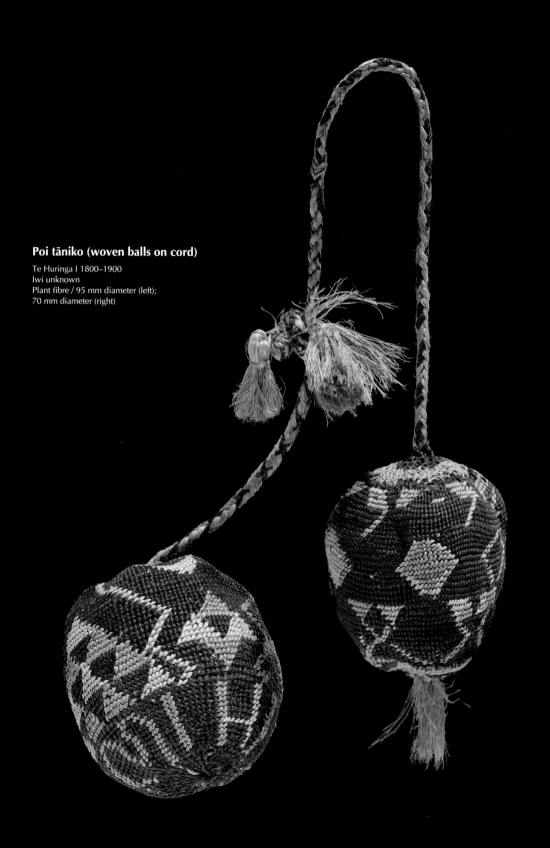

Poi tāniko (woven balls on cord)

Te Huringa I 1800–1900
Iwi unknown
Plant fibre / 95 mm diameter (left);
70 mm diameter (right)

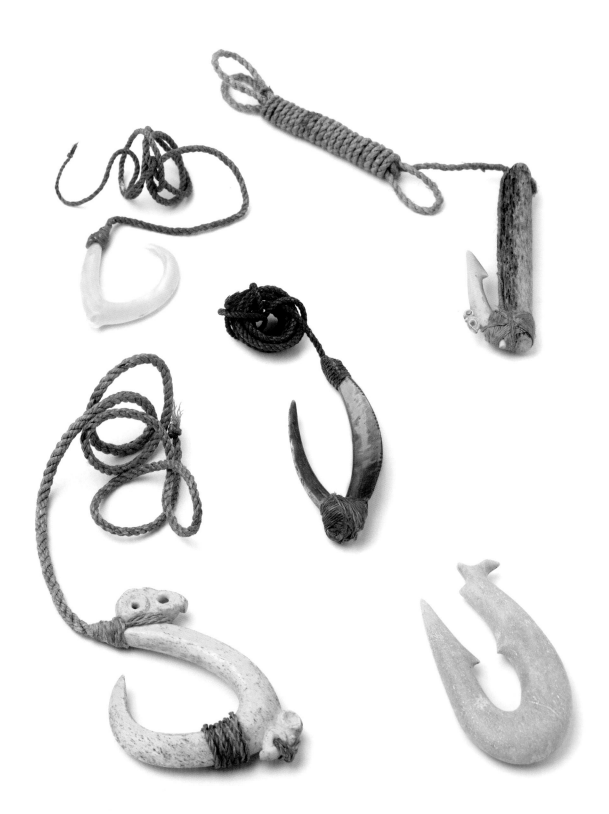

Ngā taonga a Tangaroa

The net goes fishing

Fishing was essential to survival for Māori. Fish were abundant in the seas and bays surrounding the main islands. The coast was also the source of many kinds of shellfish. Lakes and rivers provided various freshwater species.

Fishing was an activity anchored in spiritual beliefs and strong communal values. Kaitiakitanga (guardianship and care for resources) was observed in the management of fishing grounds at sea. Māori fished by their own lunar calendar – the maramataka. They understood the seasonal cycles of fish and the local environment, and were able to fish successfully and sustainably. The maramataka ensured that fishing, on which everyone depended, was based on the rhythms of the natural world.

Manaakitanga (respect and care for one another) was expressed in the catching of fish for food, as well as in hunting, cultivating and harvesting. Fish were seen as the descendants of Tangaroa, god of the sea. Rituals and protocols were an important way to ensure his favour and protect the abundance of the sea. Karakia, asking for a full net or inviting many fish to the hook, were offered to Tangaroa and other entities who protect the environment. The first fish caught was returned to the sea with a karakia for an abundant catch.

At times of fishing, no eating, cooking of food, or fouling the shore with gutted fish were permitted. No human wastes were allowed to enter the sea or waterways for obvious reasons of health and wellbeing. If a person drowned, a rāhui (restriction) was put in place and no one could fish in the area until the body was recovered. This was out of respect for those taken by the tides. Rāhui also marked out areas to protect them from over-fishing.

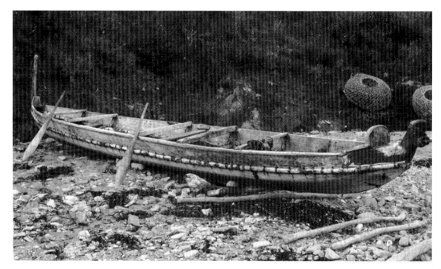

Waka on the shore, showing tāruke – pots for catching crayfish – in the background.

Photograph by Augustus Hamilton

Depending on the species sought, Māori fished predominantly with nets and traps, but hooks, sinkers and lines were also used. All of these objects were not only functional, but were often finely made – an expression of the deep respect in which Tangaroa was held.

Fish and other seafood remain an essential food source for Māori. Providing food for guests, particularly at important events, is a way of showing manaakitanga. Food from the sea ranks highly in expression of manaakitanga.

Imitating a fish

Pacific-style trolling lures were made of stone, bone and shell. In New Zealand they became pā kahawai – the local Māori form of the trolling lure. The pā kahawai was a specialised hook for catching voracious surface-feeders such as kahawai and barracuda. The pāua shell lure imitated the flashing colour of the small fish that kahawai and barracuda feed on. The lure opposite is made up of a number of different materials that may have been recycled from different sources. It was very unusual for a fishing barb to have been made from the precious pounamu. This part of the hook may originally have been a bird spear barb.

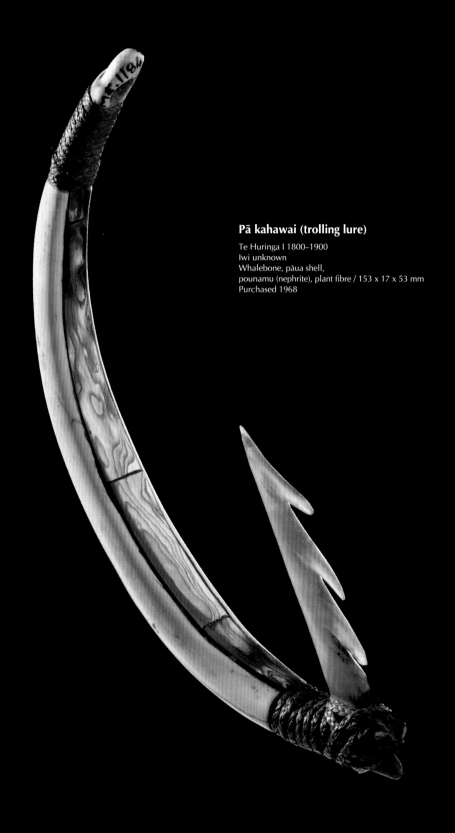

Pā kahawai (trolling lure)

Te Huringa I 1800–1900
Iwi unknown
Whalebone, pāua shell,
pounamu (nephrite), plant fibre / 153 x 17 x 53 mm
Purchased 1968

Hooking the fish

Lines and hooks were very popular for catching hāpuka – a coastal dwelling fish – as well as kahawai and barracuda. Lines were made of processed flax fibre twisted into cord, and were consequently very strong. Hooks varied in size and shape, and were carved from wood, bone, stone or shell. The hooks in this book show the variety of materials used, and how shapes differed according to the type of fish caught. The hook overleaf has a pāua section which probably acted as a lure of glistening colour.

Pohau mangā (barracuda fish-hook)

Te Huringa I 1800–1900
Te Whānau-a-Apanui; from East Cape region
Bone, fibre / 106 x 12 x 22 mm
Purchased 1987

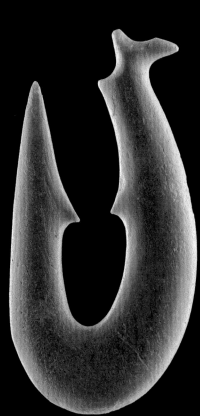

Matau (fish-hook)

From top:

Te Huringa I 1800–1900
Iwi unknown
Bone, flax fibre / 100 x 46 x 8 mm

Te Huringa I 1800–1900
Iwi unknown
Bone / 78 x 39 x 12 mm
Gift of Captain John Bollons, 1931

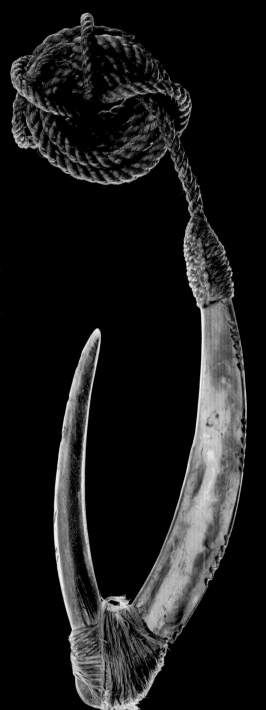

Matau (fish-hook)

Te Huringa I 1800–1900
Iwi unknown
Pāua shell, wood, fibre / 121 x 31 x 13 mm
Purchased 1948, as part of the Oldman Collection

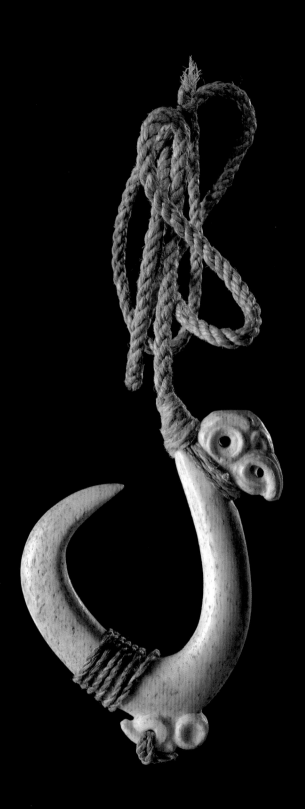

Matau (fish-hook)

Te Puāwaitanga 1500–1800
Iwi unknown
Bone, fibre / 80 x 53 x 12 mm
Gift of W Leo Buller, 1911, from
the Sir Walter Buller Collection

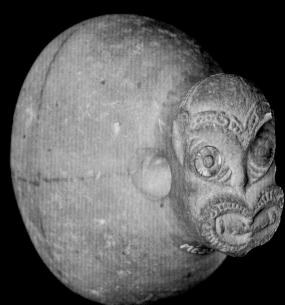
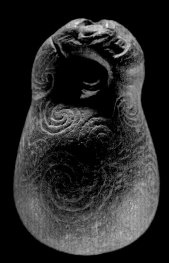
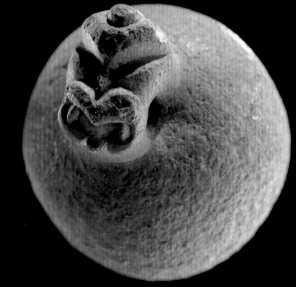

Māhē (fishing sinker)

Clockwise from top:

Te Puāwaitanga 1500–1800
Iwi unknown
Greywacke / 73 x 45 x 44 mm
Purchased 1948, as part of the Oldman Collection

Te Puāwaitanga 1500–1800 or Te Huringa I
1800–1900
Te Whānau-a-Apanui; from East Cape region
Stone / 85 x 70 x 70 mm
Purchased 1904, as part of the Hill Collection

Te Puāwaitanga 1500–1800 or Te Huringa I
1800–1900
Te Aitanga-a-Hauiti, Ngāti Whakarara, Ngāti Hau;
found at Anaura Bay, East Coast
Stone, pāua / 110 x 90 x 90 mm
Purchased 2005

Weighting the net

Fishing was predominantly done with nets – hauling for fish on the coast or placing nets at sea cast from waka. Māhē (fishing sinkers) ensure that nets sink to desired depths both for tidal estuary hauls and when the nets are set at sea – hence the reason sinkers are made from stone.

Customary fishing practices were governed by tides, seasonal conditions and ecological knowledge. The spirals carved on the māhē opposite (top) may symbolise the interrelationships, honoured by coastal tribes, of all things related to the sea – the sea god Tangaroa, the ocean itself, the fish that live in it and the people for whom it provides sustenance.

These stone māhē with carved faces indicate the reverence with which Māori approached many aspects of fishing and may have had a ceremonial function. Every item associated with the practice was made with great respect and the appropriate visual language.

Fishing from shore with nets, Waiapu, East Cape, 1923.
Photograph by James McDonald

Woven traps

Specialised nets and traps were used for fishing different species. Women of the Ngāi Tūhoe tribe caught freshwater fish in the rivers of the inland North Island using a kupenga (drag net) like the one opposite. Only a few of these nets are known to exist today.

The most commonly used trap was a hīnaki (eel trap). Tuna (eels), abundant in rivers and lakes, were an important source of food for Māori. The hīnaki was set in open water with bait, or used at pā tuna (eel weirs – fences in the water that guided the eels into the hīnaki via a net). The finest hīnaki were intricately woven objects showing great skill and finesse.

The hīnaki was anchored with stones and tied to a stake driven into the streambed. Ordinary hīnaki (hīnaki tukutuku) had one entrance. When they were set independently of a weir, the entrance faced downstream. The eels smelt the bait, and would swim upstream to find it. An eel lured into a baited hīnaki could not escape through the narrow neck.

Tau Tamakihu and an unknown man making hīnaki, Whanganui River region, 1912–26.

Photograph by James McDonald

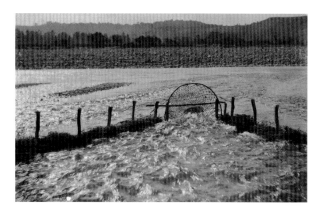

Fish trap in the Waiapu River, East Cape, 1923.

Photograph by James McDonald

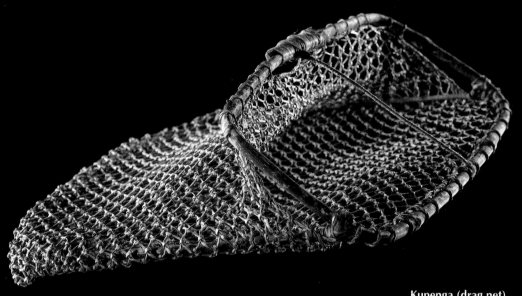

Kupenga (drag net)

Te Huringa I 1800–1900
Iwi unknown
Vine, New Zealand flax / 140 x 503 x 402 mm

Hīnaki (eel trap)

Te Huringa I 1800–1900
Te Āti Haunui-ā-Pāpārangi (attributed); from
Whanganui region
Vine, New Zealand flax / 260 x 280 x 580 mm

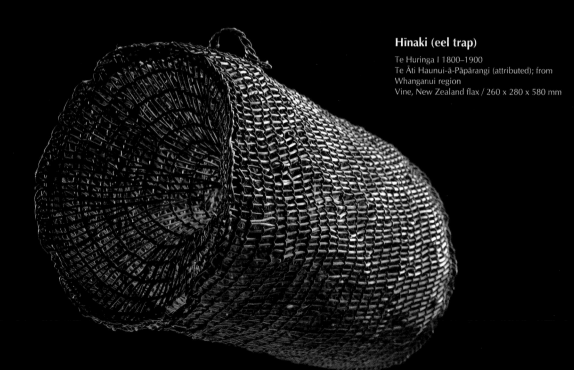

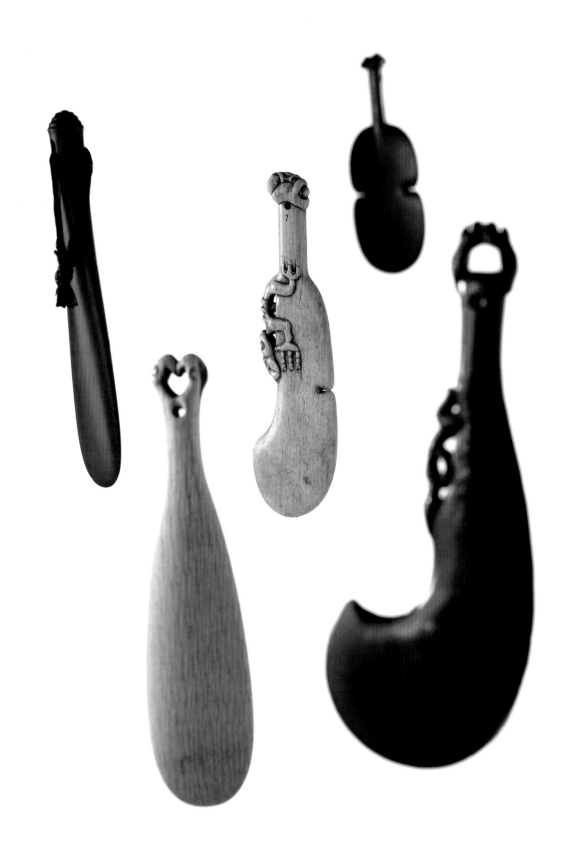

Ngā rākau a Tū

The legacy of the warrior

E Tū te riri, e Tū te ngiha.
Unleash the god of war, unleash the fires of destruction.

The origins of human conflict in Māori tradition are found in the separation of the primal parents. Locked in an eternal loving embrace, Ranginui and Papatūānuku were separated by their children who lived in the dark realm between their parents. Tūmatauenga, the fiercest and boldest of their children, wanted to kill his parents and break free from their constraints, but many of the other children wanted only to separate them.

Tāwhirimātea (god of winds) did not want to separate his parents at all and waged war against his siblings with violent storms and winds. Eventually Tāne Mahuta (god of the forest) braced his shoulders against his mother and his feet against his father. Slowly he forced his parents apart until Ranginui stood high above, while Papatūānuku was left lying below. The children then struggled among themselves for dominion of the world, and each gained a part of it. Tūmatauenga (Tū) governs all aspects of human conflict and ngā rākau a Tū refers to the Māori warrior's array of weaponry.

The causes of conflict and war are complex and varied. For Māori, they often arose around disputes over and competition for territory and resources, retaliation for insults, and for attacks on people or mana. The collapse of personal relationships could even destabilise tribal alliances and start wars – especially when people of status were involved.

The skills, techniques and protocols required to conduct warfare were taught in the whare tū taua (school of martial knowledge). Young boys and girls were trained in martial skills, usually in the form of games, from early childhood. During adolescence they were routinely schooled in the arts of close-quarter combat using a range of both short-handled and long-handled weapons. Young men of rank who were particularly adept with weapons and displayed strong leadership qualities were often expected to specialise in combat tactics and military strategy.

A warrior's reputation was earned on the battlefield. Champions would call each other out to test their skills in intense duels. Tribal champions won great fame, and their exploits were celebrated in songs and chants, and recorded in the oral histories of their people.

Weapons too acquired fame and notoriety, mostly through association with renowned warriors and chiefs. The weapons of a warrior were given personal names, and possessed both mana and tapu. Weapons gained mana through association with courageous warriors responsible for protecting the whānau, hapū and iwi from outside aggressors. These warriors also preserved the collective mana of the tribe through successful battles.

Warriors entered into a state of tapu when preparing for combat. Their weapons acquired tapu by association, and also because of their connection with blood and death. Many weapons were said to possess supernatural powers, and some were considered so tapu that people feared them and would refuse to handle or approach them for fear of sickness or misfortune.

Symbols of identity

Customary Māori weapons are more than instruments of death. They are also symbols of identity and chieftainship, representing the personal and in some instances collective authority of their owners.

The pragmatic warrior was quick to adopt the gun, which became essential in the arms race that followed its introduction. Some butts of guns used during the land wars of the 1860s were intricately carved, but the gun never acquired the revered personal status of weapons such as the mere pounamu or the taiaha. Māori continued to fight with customary weapons through the New Zealand wars of the 1860s. Māori soldiers are also known to have taken customary weapons, particularly the mere pounamu, to the Boer War and both world wars.

The legacy and the spirit of the warrior continue to thrive today in contemporary schools of Māori martial arts, through kapa haka (Māori performing arts) competitions, in the New Zealand Army, and political protest. Māori orators continue to wield customary weapons to add drama and emphasis to their speechmaking on ceremonial occasions.

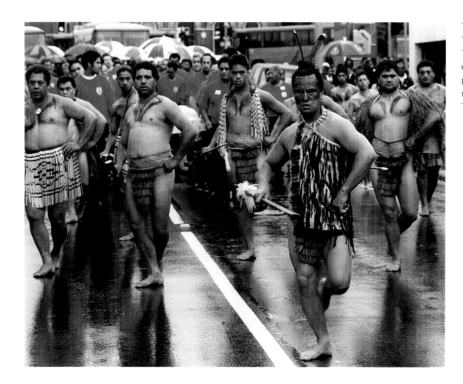

The cultural performance group Te Matarae i o Rehu, led by Te Wētini Mita (foreground), escorting the components of the pātaka whakairo Te Tākinga to its new location at Te Papa, 1997. The men are armed with taiaha.

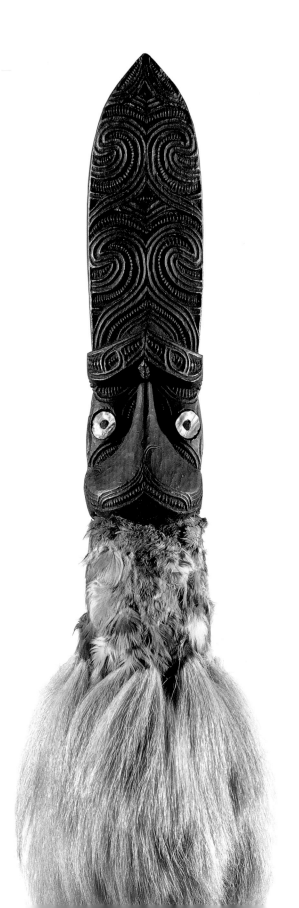

**Taiaha kura (chief's long
fighting staff) called
Te Rongotaketake**

Early Te Huringa I 1800–1900
Ngāti Ira Kaipūtahi
Wood, kākā feathers, dog hair, flax fibre,
rushes, pāua shell / 1760 x 40 x 60 mm
Purchased 2002

The weapon of a chief

The most prestigious of the long-handled weapons is the taiaha kura (chief's long fighting staff). One end of this taiaha is the striking blade. The other end is carved as a head with a face on each side. The face has an elaborately carved protruding tongue, and the eyes see in all directions, exemplifying the alertness of the warrior. The red parrot feathers and white dog hair mark this as the weapon of a chief. It has a personal name, Te Rongotaketake, and is distinguished by its carved head and elaborately carved protruding tongue.

Weapons of great status were sometimes exchanged to seal peace agreements. This taiaha was passed between Ngāti Ira Kaipūtahi and Ngā Puhi in about 1819 in an effort to end hostilities between them. Around 1847, Te Rongotaketake was again given as a symbol of peace, this time to Auckland Police Commissioner James Naughton, by Ngāti Hine chief, Te Ruki ('The Duke') Kawiti, a key military strategist in the struggles against British sovereignty in the 1840s.

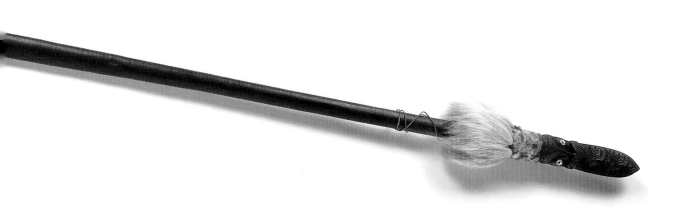

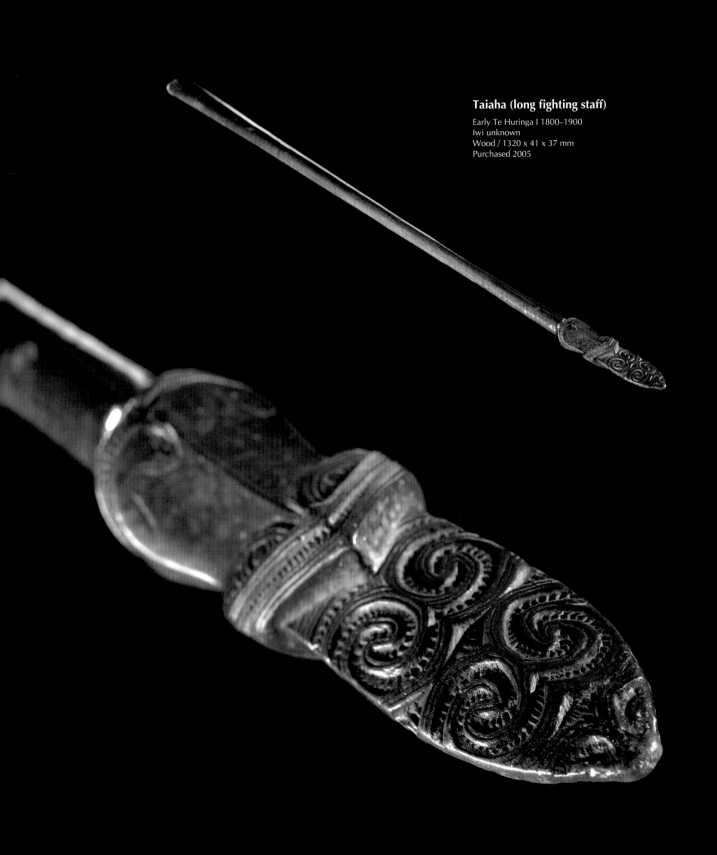

Taiaha (long fighting staff)

Early Te Huringa I 1800–1900
Iwi unknown
Wood / 1320 x 41 x 37 mm
Purchased 2005

European technology

Māori readily adapted new technology to meet their own needs, particularly to avoid spending the many laborious hours involved in manufacturing customary stone weaponry. This toki kakauroa (long-handled tomahawk) shows a European axe-head fixed to a long handle that can also be used for thrusting and parrying.

Toki kakauroa (long-handled tomahawk)

Te Huringa I 1800–1900
Ngā Puhi, Ngāti Tautahi hapū
Wood, metal / 1070 x 103 x 25 mm
Purchased 1904

Toiroa Te Hou Kōtuku (Ngāti Whakaue), performing a
sequence of manoeuvres with the taiaha at Tamatekapua
meeting house, Ohinemutu, Rotorua, 1905.

Photograph by Thomas Pringle
Alexander Turnbull Library 1/1-006825-G,
1/1-006826-G, 1/1006827-G, 1/1-006828-G

Pouwhenua (long-handled fighting weapon)

Early Te Huringa I 1800–1900
Iwi unknown
Wood / 1782 x 175 x 37 mm
Purchased 1958, as part of the Webster Collection

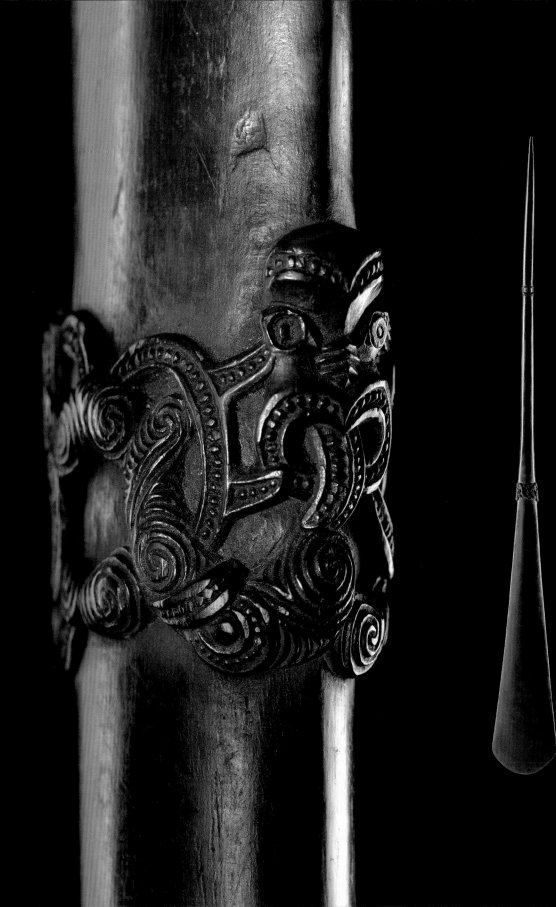

Symbol of authority

The hoeroa is both a ceremonial staff and a weapon. Usually owned by high-ranking men, hoeroa were symbols of prestige and authority. They were made from the jawbone of the sperm whale and often had fine carving on parts of them. The hoeroa opposite is carved with the name of Hōne Mohi Tāwhai, a tribal leader and parliamentarian. Tāwhai presented it to a Christian church leader, the Reverend William Rowse, between 1863 and 1878.

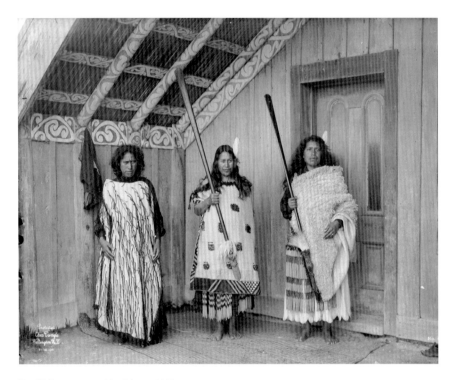

Ngāi Tūhoe women with taiaha, *c.* 1905.

Photograph by Thomas Pringle
Alexander Turnbull Library, A E Birch Collection 1/1-007011-G

Hoeroa (chief's ceremonial staff)

Te Puāwaitanga 1500–1800
Ngā Puhi, Te Māhurehere hapū
Whalebone / 1270 x 78 x 10 mm
Gift of A D Rowse, *c.* 1944

Short-handled weapons

Patu have a broad oval blade that tapers to a handle. These weapons are designed for specific fighting manoeuvres. The warrior used them to attack his opponent's head and body with short, sharp, thrusting movements. Striking with the leading edge, he could inflict grievous injury and even cause death. Maimed warriors were often carried from the field of battle as trophies and executed. A high-ranking chief might be executed by the single blow of a mere pounamu to the temple, or decapitated by a toki poutangata.

Specialised forms of the patu include the kotiate, with a flat, notched blade; the wahaika, made of wood or bone; and the mere, a stone weapon often made from pounamu. These weapons were secured to the hand with a wrist thong to ensure they were not lost during battle. Fine workmanship is evident in all of the patu illustrated in this book. Pictured overleaf is a stone patu which has been shaped and polished to an extraordinarily even surface, and a whalebone wahaika with a human figure carved on the handgrip.

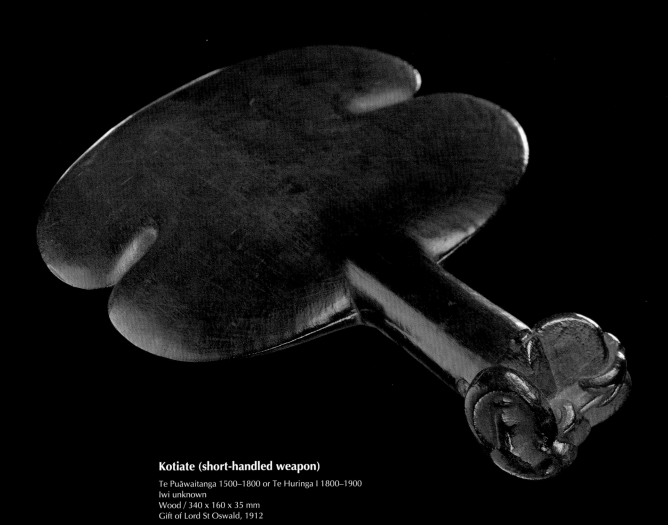

Kotiate (short-handled weapon)

Te Puāwaitanga 1500–1800 or Te Huringa I 1800–1900
Iwi unknown
Wood / 340 x 160 x 35 mm
Gift of Lord St Oswald, 1912

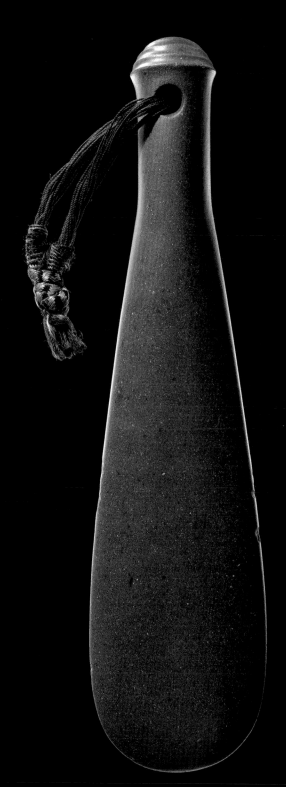

**Patu ōnewa (short-handled
stone weapon)**

Early Te Huringa I 1800–1900
Iwi unknown
Stone, silk cordage / 370 x 93 x 30 mm
Purchased 1979

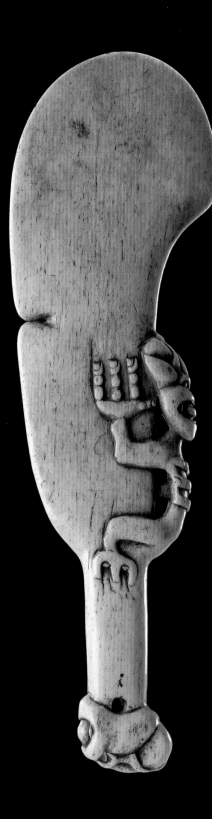

Wahaika parāoa (short-handled whalebone weapon)

Te Puāwaitanga 1500–1800
Iwi unknown
Whalebone / 356 x 109 x 20 mm
Acquired 1921, as part of the
Purvis Russell Collection

An old and famous weapon

The most prestigious of the short-handled weapons is the mere pounamu. It was both a highly effective weapon and a symbol of chiefly authority. This old and famous mere pounamu is associated with several renowned tribal chiefs of the southern North Island. It has a personal name, Tawhito Whenua, and in the early nineteenth century was owned by Te Kēkerengū, a rangatira of the Ngāti Ira Kaipūtahi tribe.

During intertribal fighting, Ngāti Toa chief Te Rangihaeata captured Te Kēkerengū and his mother, Tāmairangi, a rangatira in her own right. As they were about to be executed, this chiefly woman sang a song of farewell to her ancestral lands. Her song was so moving that Te Rangihaeata spared their lives. Eventually, this weapon passed from Ngāti Toa to Ngāti Kahungunu. In 1917, it was known to have been in the collection of Airini Donnelly, a high-ranking woman of that tribe.

Te Rangihaeata (Ngāti Toa), warrior chief and tohunga, 1840. He was presented with the mere pounamu opposite by Te Kēkerengū.

Watercolour by Charles Heaphy
Alexander Turnbull Library C-025-022

Hōhepa Tamaihengia (Ngāti Toa), 1880s. He inherited the mere pounamu opposite after Te Rangihaeata's death in 1855.

Detail from a photograph of two Ngāti Toa chiefs and their wives.
Alexander Turnbull Library F-97094-1/2

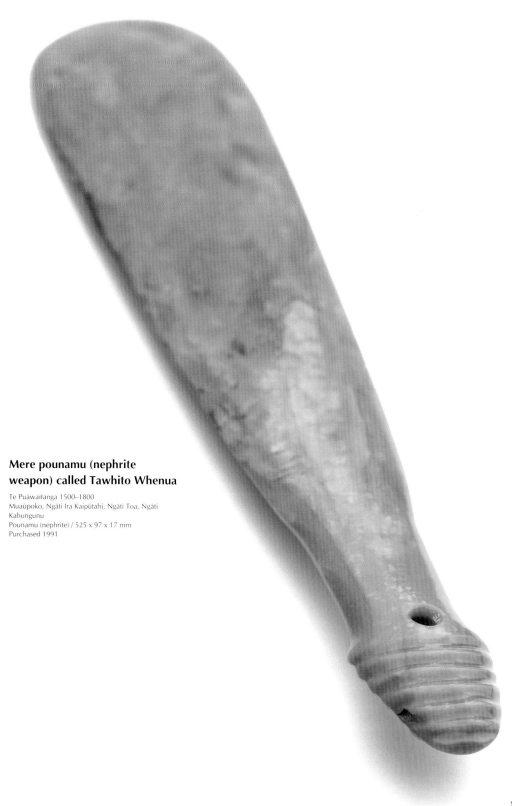

Mere pounamu (nephrite weapon) called Tawhito Whenua

Te Puāwaitanga 1500–1800
Muaūpoko, Ngāti Ira Kaipūtahi, Ngāti Toa, Ngāti Kahungunu
Pounamu (nephrite) / 525 x 97 x 17 mm
Purchased 1991

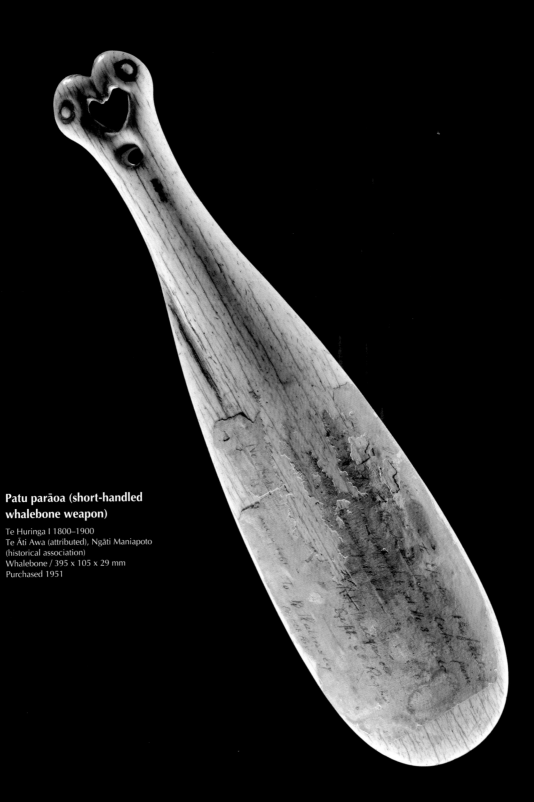

**Patu parāoa (short-handled
whalebone weapon)**

Te Huringa I 1800–1900
Te Āti Awa (attributed), Ngāti Maniapoto
(historical association)
Whalebone / 395 x 105 x 29 mm
Purchased 1951

Carved whalebone

This beautifully proportioned patu is made of bone from a sperm whale's jaw. Whalebone was particularly suitable for weapons because of its hardness and durability. Carved at the butt are two bird-like figures joined at the beak. This bird form is thought to be very old. Below the bird figures is a hole for a wrist thong.

In 1861, during the New Zealand Wars, warrior chief Epiha Tokohihi retrieved this patu from the body of a fallen comrade who had been killed in an attack on a British garrison in Taranaki. In that encounter many Māori were armed with guns, but they also carried traditional weapons for hand-to-hand fighting.

Ēpiha's tribe Ngāti Maniapoto suffered severe losses in the Taranaki campaigns. These were recalled in this waiata tangi (lament) composed for the dead of the tribe after one of the battles:

Kāore taku hūhi, taku raru, ki a koutou,
e pā mā, e haupū mai rā!
Ka hua hoki au ki a Ēpiha mā e hui nei ki te rūnanga,
he kawe pai i te tika.
Kāore he mahi nui i ngā maunga a Whiro kua wareware.

Alas, my grief, my desolation for you noble ones
heaped up among the dead!
Once I listened to Ēpiha and his chiefs in council,
and I thought their words were good and true.
On the dark hills of death their plans were brought to nothing.

Camp of the British Army's 65th Regiment, Waitara, Taranaki, 1860.

Watercolour by Charles Emilius Gold
Alexander Turnbull Library B-103-011

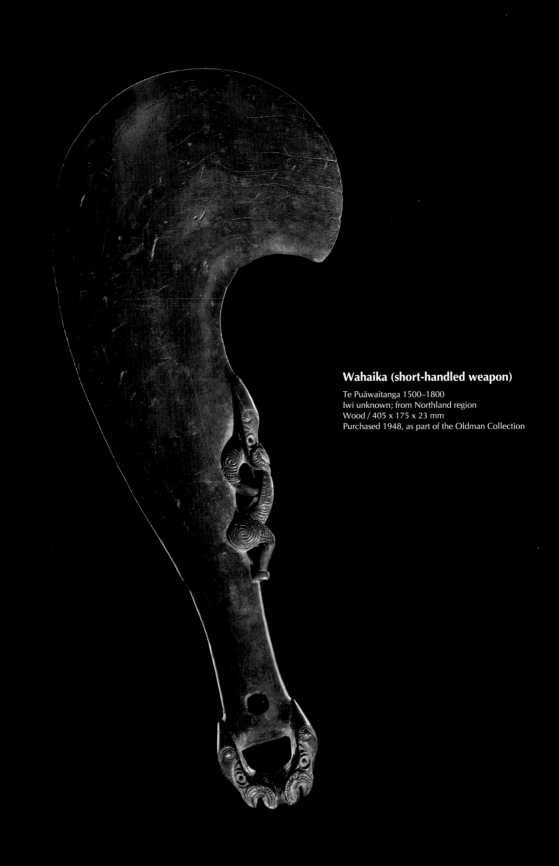

Wahaika (short-handled weapon)

Te Puāwaitanga 1500–1800
Iwi unknown; from Northland region
Wood / 405 x 175 x 23 mm
Purchased 1948, as part of the Oldman Collection

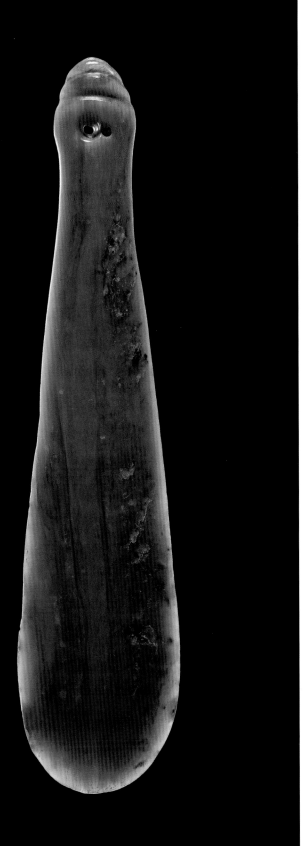

A place in history

To mark the signing of the Treaty of Waitangi, Eruera Maihi Patuone, one of the principal chiefs at the signing, presented this mere pounamu to the British government's representative, William Hobson. Hobson's descendants later gifted it back to the people of New Zealand.

Eruera Maihi Patuone (right) and Hōne Heke, 1847.

Plate 1 in *The New Zealanders Illustrated* by George French Angas, hand-coloured lithograph by W Hawkins

Mere pounamu (nephrite weapon)

Te Puāwaitanga 1500–1800 or early Te Huringa I 1800–1900
Ngā Puhi
Pounamu (nephrite) / 381 x 88 x 33 mm
Gift of Department of Internal Affairs, 1961

Kākahu and whatu raranga

Woven garments, woven treasures

Weaving is more than just a product of manual skills. From the simple rourou [food basket] to the prestigious kahu kiwi [kiwi feather cloak], weaving is endowed with the very essence of the spiritual values of Maori people. The ancient Polynesian belief is that the artist is a vehicle through whom the gods create.

Erenora Puketapu-Hetet [4]

The first people in Aotearoa New Zealand brought the knowledge of weaving with them. They also brought aute (paper mulberry), a plant used for making tapa cloth in their Pacific homeland. But aute proved difficult to grow in the cooler climate of the new country. To survive, these early settlers had to find other materials for weaving. Harakeke (*Phormium tenax*) proved an important resource for both its leaves and its fibre. Over time, other plant materials came to be used, as well as the hair and skin of dogs, and feathers.

Women were the main practitioners of the art of weaving, which they learnt in the whare pora (house of weaving). This was probably not so much a physical house as a body of knowledge, both technical and spiritual. The weavers slowly acquired this knowledge, working under the eye of Hine-te-iwaiwa, the deity of weaving. In all their practices they maintained a respectful relationship with Papatūānuku. One generation of women passed their knowledge of weaving to the next.

Master weaver Erenora Puketapu-Hetet
(Te Āti Awa), removing the muka from
the green harakeke leaf with a mussel
shell, 1988.

Harakeke became the preferred material for weaving. The long leaves were split into strips, or scraped with a mussel shell to extract the muka (a silky white fibre) – a technique still used today. The muka was rolled into fine cords to be woven for soft garments such as cloaks. Early Europeans called harakeke 'flax' because of the muka – the plant is no relation to linen flax, but muka resembles linen flax's lustrous fibre.

Strict protocols and restrictions were observed in both the gathering of materials for weaving and the weaving itself. In the harvesting of flax, for example, the three innermost growing shoots, representing a child and its parents, were never cut. Protocols like this are still observed, and ensure that the flax continues to grow well. Knowledge of history, protocols, language and tribal traditions remain part of the skill base of an accomplished weaver.

Weavers mastered many techniques to produce everyday items as varied as baskets, belts, sandals, kites and clothing. They adapted the technology of whatu (twining), used in netting and baskets, to make protective garments such as pākē (rain capes). But the culmination of the weaver's art was the making of magnificent cloaks. These cloaks were distinguished by both the quality of their materials and the fine work involved. They often took many months to make. They became powerful symbols of rangatiratanga – of leadership, chiefly authority and status.

Cloaks continue to be highly valued. They are worn for ceremonial and important occasions, bringing honour to both wearer and occasion. As they are passed down from generation to generation, they acquire the mana of the ancestors who have worn them. Giving a cloak to, or allowing it to be worn by, a distinguished guest demonstrates manaakitanga. Kaitiakitanga is expressed in the warmth and shelter provided by the cloak itself. The act of a chief throwing a cloak over a condemned person could save the person from death.

The textiles in this book demonstrate the skill and artistry of Māori weaving up to the early twentieth century. In the 1950s, education programmes and national bodies such as the Māori Women's Welfare League acted to preserve and maintain weaving, and highlighted the need to protect the natural resources important to weaving.

Weaving today is no longer solely the domain of women. It can be learnt and enjoyed by anyone. Its practitioners continue to be highly innovative, and weaving has influenced many contemporary forms of Māori artistic expression. Weavers today combine this innovation with a deep respect for traditional practice, maintaining and strengthening this highly skilled art.

Cloaks displayed at the tangi (funeral rites) of Porokoru Pātapu, Putiki, Wanganui, 1917.
Alexander Turnbull Library 1/2-008285-F

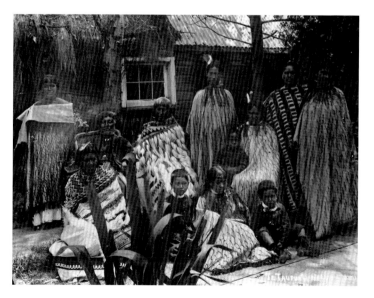

Te Taupua Moturoa (Te Āti Awa) and his family wearing a range of cloaks, c. 1900.
Alexander Turnbull Library, Esme Harris Collection 1/2-113796-F

Guarding and welcoming

The figure opposite represents the female spirit present in every part of the weaving process. The figure was originally part of a pou tokomanawa, the central support post of a meeting house. The moko kauae or chin carving on her face indicates high rank, signifying her status as a chiefly ancestor. This carving has been used in national and international exhibitions. It has also been located in Te Papa's weaving storeroom, as a guardian of the distinguished cloaks and of weaving specialists who come to study the collection held there.

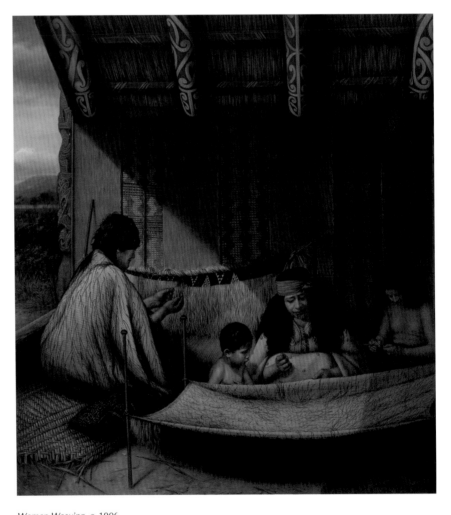

Women Weaving, c. 1906

Oil paint on canvas by Gottfried Lindauer
Auckland Art Gallery Toi o Tāmaki, purchased 1915

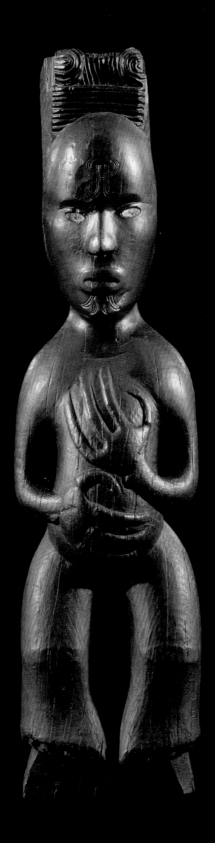

**Pou tokomanawa
(central support post)**

Te Huringa I 1800–1900
Ngāti Kahungunu (attributed)
Tōtara wood, pāua shell /
870 x 220 x 165 mm

A chief's garment

Among the most prestigious of cloaks were kahu kurī (dogskin cloaks). Explorer James Cook, who first visited New Zealand in 1769, observed that the kahu kurī was worn as a mark of leadership. One account from Cook's voyages tells of a waka approaching his ship. As it came closer a man stood up in the waka and put on a kahu kurī. This action signified his status, and once on board the ship he addressed Cook as his equal.

Kahu kurī were made of strips of skin taken from the kurī, the Pacific dog that came with the early arrivals. The strips were arranged by hair colour, then sewn with painstaking precision to a foundation of tightly woven flax fibre. Longer hair formed the luxuriant fringe and collar of the cloak. Each kahu kurī had a personal name and a carefully preserved history. On ceremonial occasions these cloaks were often exchanged between people of rank, in recognition of the high status of both giver and receiver. By the 1870s the kurī had disappeared as a breed, and kahu kurī were no longer made. Fine flax cloaks and feather cloaks became key symbols of chiefly prestige.

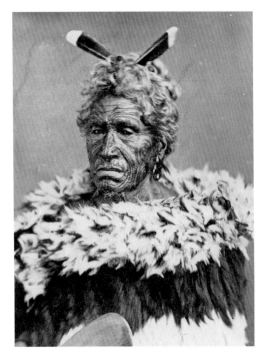

Unknown man wearing a kahu kurī, 1870s–80s.

**Kahu kurī
(dogskin cloak)**

Te Huringa I 1800–1900
Te Āti Awa (attributed)
Flax fibre, dogskin strips /
1190 x 1090 mm
Gift of W Leo Buller,
1911, from the Sir Walter
Buller Collection

Kahu kiwi (kiwi feather cloak)

Te Huringa I 1800–1900
Iwi unknown
Flax fibre, brown and albino kiwi feathers /
1700 x 1500 mm
Acquired c. 1905

Unique feathers

This kahu kiwi is made from feathers of the kiwi, a flightless bird unique to New Zealand. The darker feathers are from the common brown kiwi, while the white feathers are from a rare albino variety. These stripes are mirrored by stripes of dyed fibre inside the cloak. In the Māori world, birds were messengers between people and gods. The kiwi in particular was a bird of great significance, descended from Tāne Mahuta. The weaver has skilfully woven the feathers into the fibre backing so that they turn outwards. The distinction of this cloak comes from its unique materials and the artistry of its design and making.

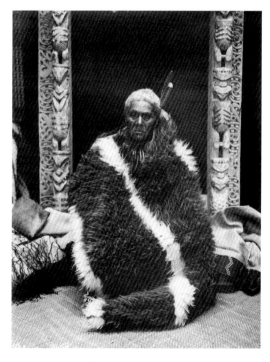

Hārata Te Kiore (Te Āti Haunui-ā-Pāpārangi), wearing a kiwi feather cloak, 1901–13.

Photograph by Augustus Hamilton

This detail of the kiwi feather cloak opposite shows how each feather has been woven so it turns outwards, creating a lush texture.

Silk sheen

Kaitaka (fine flax cloaks) became the most prestigious form of customary Māori dress from the time of early European settlement of New Zealand until the mid nineteenth century. The silky look and golden sheen of the kaitaka paepaeroa opposite come from the fineness of muka used in its weaving. The kaitaka has a border woven in a precise geometric design called tāniko. The weaver has worked a small pattern in woollen yarn into the main part of the cloak.

Kaitaka pātea (cloak with patterned border)

Te Huringa I 1800–1900
Iwi unknown
Flax fibre, dog hair / 1400 x 2180 mm
Purchased 1981

Kaitaka paepaeroa (cloak with vertical weft threads and patterned borders)

Te Huringa I 1800–1900
Te Arawa
Flax fibre, wool / 1040 x 1780 mm
Gift of Dr and Mrs C Morice, 1967

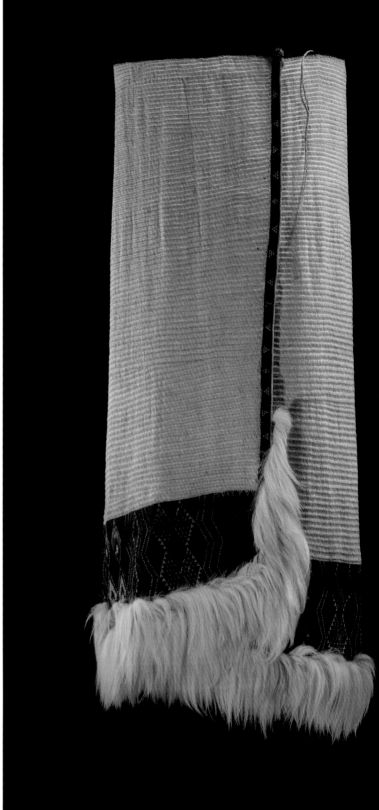

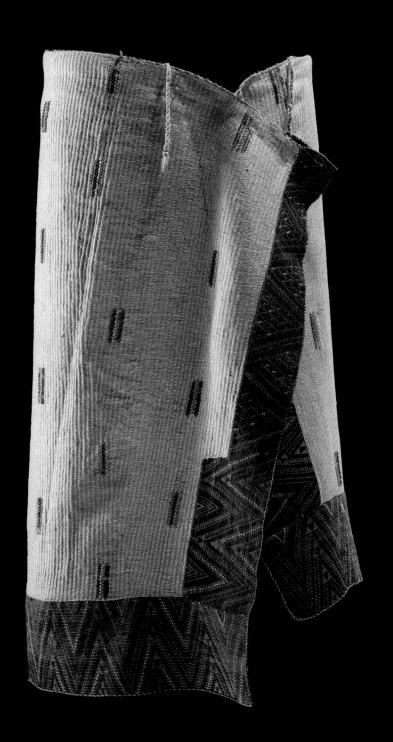

Finely woven wraps

The weaver of the beautiful child's wrap opposite (top) was Eterina Hokokākahu Āperahama, a chief's daughter. In 1875, Eterina was employed by a European man, Charles Rogers, to look after his newborn daughter, Florence. Immediately, Eterina began to weave a garment suitable to wrap the baby in. The wrap is typical of those made for Māori children of noble birth. Eterina wove it from muka, then finished it with a fringe of European wool. Florence Rogers kept the wrap all her life. She had no children of her own, and in 1949 she presented it to New Zealand's national museum for safekeeping.

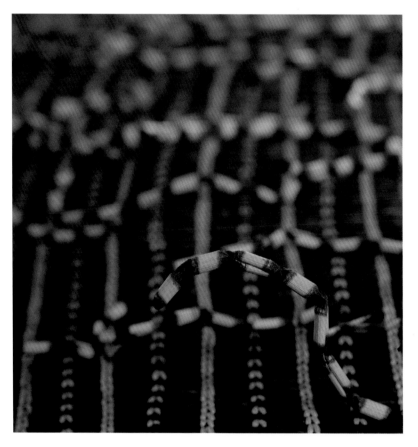

This detail of the pihepihe cloak opposite shows the cylindrical tags woven into the cloak. In this case, the weaver has alternated dyed and undyed threads to give a striking appearance.

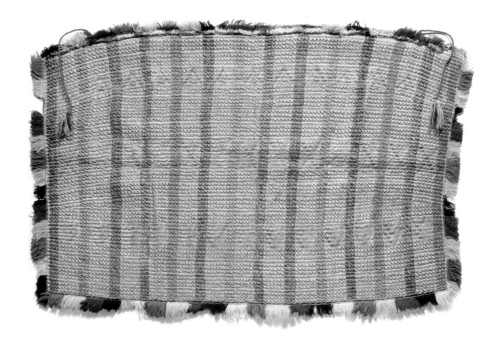

Kākahu (cloak) for child

c. 1875, Te Huringa I 1800–1900
Made by Eterina Hokokākahu
Āperahama (Te Hika-a-Pāpāuma,
Ngāti Kahungunu)
Flax fibre, wool / 790 x 1190 mm
Gift of Florence Rogers, 1949

Pihepihe (cloak)

Te Huringa I 1800–1900
Iwi unknown
Flax fibre, natural dyes / 990 x 1380 mm
Gift of W Leo Buller, 1911, from the
Sir Walter Buller Collection

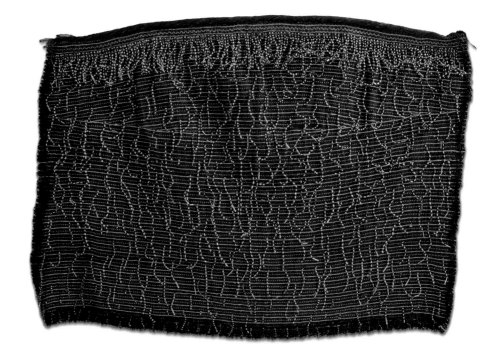

Colours of the natural world

From the mid nineteenth century, the feather cloak became the symbol of prestige, and weavers increasingly incorporated feathers into cloaks. They used feathers from both native and introduced birds in an array of innovative multicoloured patterns and designs, weaving the shafts of the feathers securely into the fabric of the garment. Weavers continue to make feather cloaks today, often using the feathers of birds killed by predators or by motor vehicles on the roads.

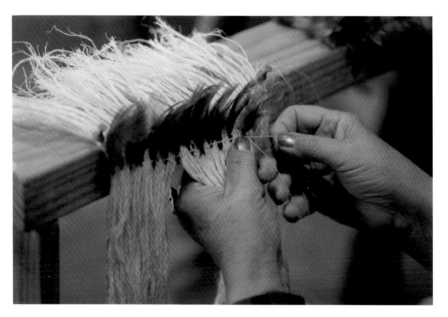

Weaving feathers into a cloak at a cloak-making demonstration, Te Papa, 2000.

A cloak of 9000 feathers

The vivid pattern of this kahu huruhuru (feather cloak) comes from feathers of native New Zealand birds. The green and white feathers are from the kererū (wood pigeon), while the red and orange feathers are from the kākā, a forest parrot. About 6100 white feathers from the lower chest and belly of kererū were used in the borders and zigzag patterns of this cloak. Some 3000 green feathers from kererū necks and upper chests were counted in the central and side patterns. Given the usual feather counts on a kererū, feathers from at least ten birds would have been used to make the cloak. Making a cloak like this took months of highly specialised work – gathering, preparing and weaving the materials. The result is a garment of great status linked to the history of a distinguished tribal matriarch.

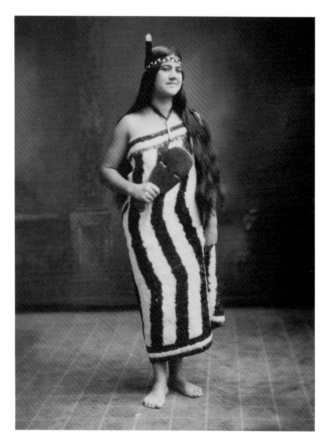

Marie Moffat, wearing the feather cloak pictured opposite, 1920s.

Photograph by Bunting Studios

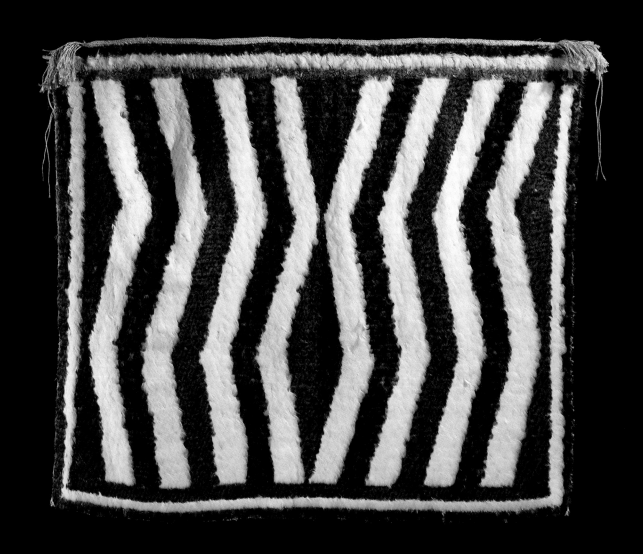

Kahu huruhuru (feather cloak)

Te Huringa I 1800–1900
Rangitāne
Flax fibre, kererū and kākā feathers / 1040 x 1190 mm
Purchased 1996

**Kahu huruhuru
(feather cloak)**

Te Huringa I 1800–1900
Ngāi Tūhoe
Flax fibre, kererū, tūī and kākā
feathers / 985 x 1455 mm
Deposited 1899, as part of
the Elsdon Best Collection

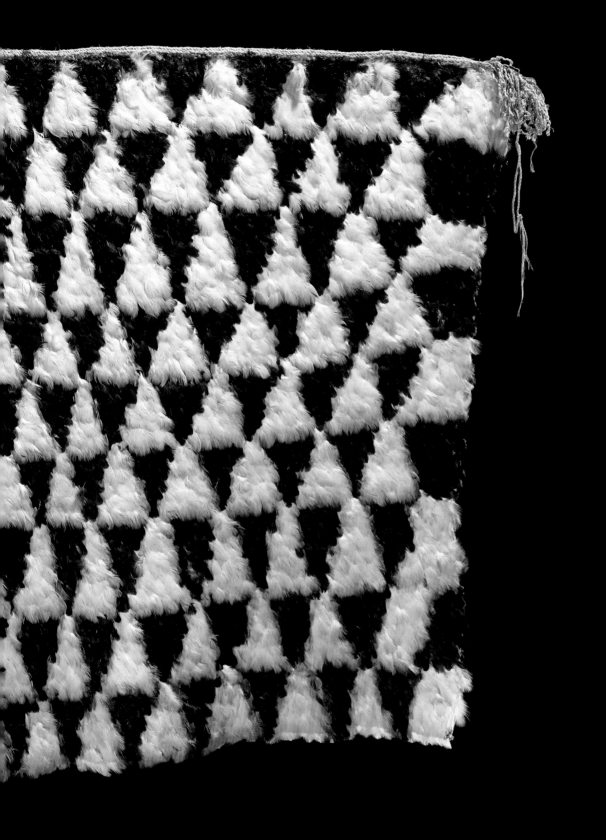

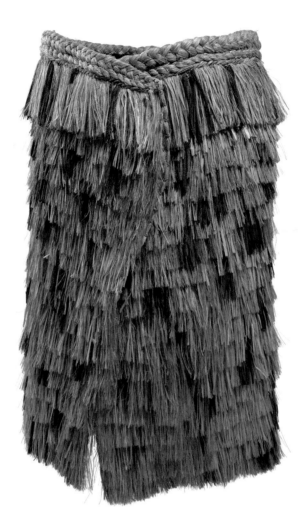

Pākē (cape)

Te Huringa I 1800–1900
Iwi unknown
Flax fibre, leaves / 890 x 1630 mm
Purchased 1905

Rain capes

Pākē are rough cloaks made to shelter the wearer from rain, wind and cold. They
were made from strips of unprocessed fibre that curled naturally into 'spouting' to shed
rainwater. Rain capes have had a revival in popularity, and many beautiful and practical
ones have been made for paddlers of modern waka.

Some pākē were worn around the waist as well as across the shoulders. The pākē
kārure (waist garments) opposite are made of strands of black and gold-dyed muka, rolled
and twisted into cords. These garments are thought to be precursors to piupiu (skirts of
flax strands hanging from a belt), now worn most commonly by kapa haka performers.

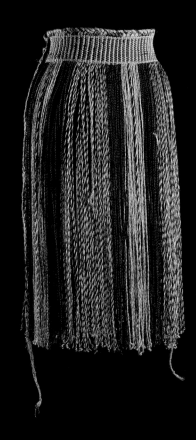

Pākē kārure (waist garment)

From top:

Te Huringa I 1800–1900
Iwi unknown
Flax fibre, natural dyes, feather remnants /
700 x 1020 mm, band 70 mm

Te Huringa I 1800–1900
Iwi unknown
Flax fibre, feathers / 1100 x 1200 x 50 mm

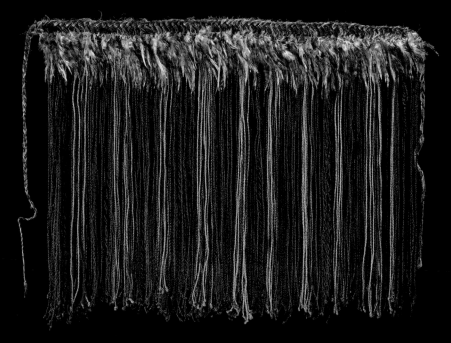

New colours and textures

The korowai is a cloak made of muka and decorated with long cords. Before European settlement, these cloaks were sometimes coloured with kōkōwai (red ochre). Later, both korowai and kaitaka featured wool yarn in their design. Māori weavers were quick to experiment with new materials and new techniques. They mixed coloured wool (adopted in the mid nineteenth century) with flax fibre in the tāniko borders of the kaitaka, and wove patterns in wool into the main body of both kaitaka and korowai.

Korowai (cloak with decorative tags)

Te Huringa I 1800–1900
Iwi unknown
Flax fibre / 1030 x 1510 mm
Purchased 2001

Korowai hihimā (cloak with white decorative tags)

Te Huringa I 1800–1900
Iwi unknown
Flax fibre / 950 x 1370 mm
Gift of A H Turnbull, 1913

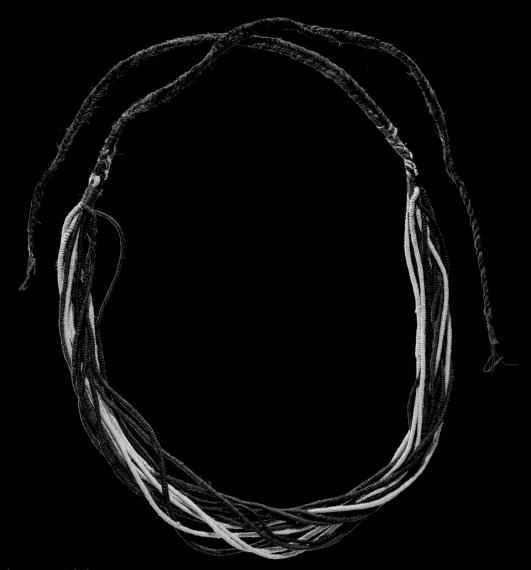

Tā muka (women's belt)

Te Huringa I 1800–1900
Ngāi Tūhoe
Flax fibre / 25 x 2050 mm
Purchased 1913

Tātua (man's belt)

Te Huringa I 1800–1900
Iwi unknown
Flax fibre, dog hair / 200 x 2870 mm
Purchased 1977

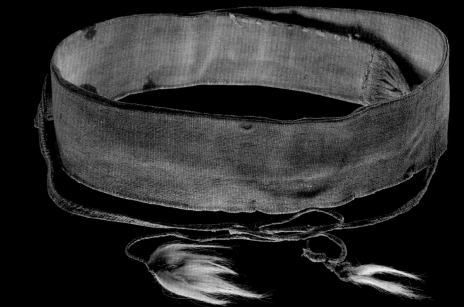

Maro hara or tātua (belt)

Te Huringa I 1800–1900
Moriori; from Rēkohu, Chatham Islands
Flax fibre, feathers / 145 x 5060 mm

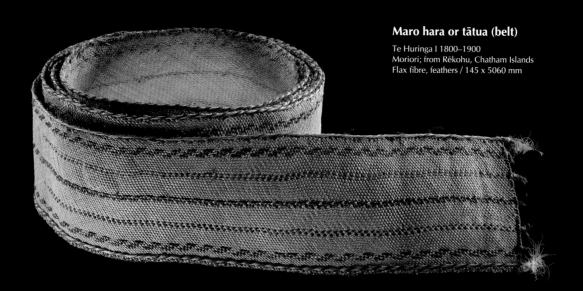

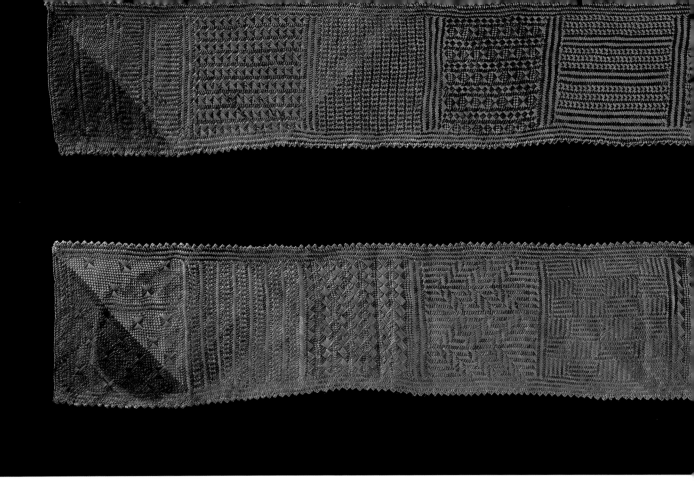

Tauira kete whakairo (weaving samplers)

Te Huringa I 1800–1900
Made by Te Hikapuhi Poihipi (Ngāti Pikiao, Ngāti Te Rangiunuora, Ngāti Whakaue)
Flax fibre / 2975 x 380 x 30 mm (top); 3350 x 400 x 27 mm (bottom)
Purchased 1914, as part of the Augustus Hamilton Collection

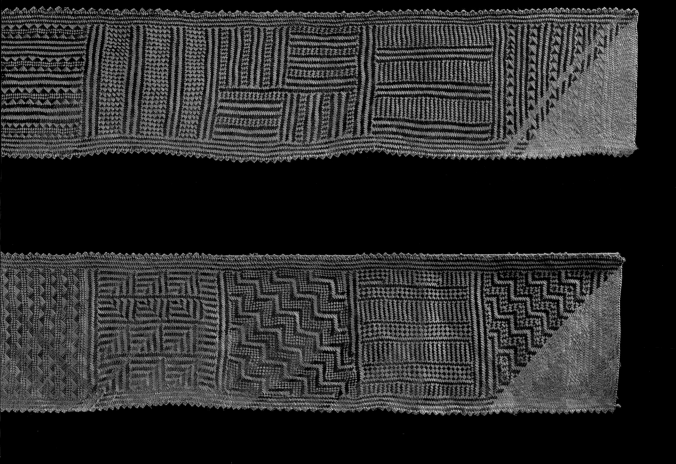

A range of patterns

These unique tauira (samplers) were made to show the different patterns used in weaving fine baskets. Each pattern has its own name and meaning. The samplers were made by Te Hikapuhi Poihipi, a healer and midwife as well as an expert weaver. Te Hikapuhi continued to practise her healing methods at a time when the government was banning practices that were based on traditional beliefs. She is one of only two women recorded as a tā moko practitioner in the early twentieth century.

Age and quality

Kete (baskets) were an important part of everyday life. Open-weave baskets could be woven quickly and were used for carrying and cooking food. Intricately patterned close-weave baskets were symbols of the natural environment, with tribally specific names for each pattern. These are still made in a variety of patterns using different techniques.

The kete tāniko (geometrically patterned bag) opposite is made of muka. It is a rare and beautiful example, woven in a variety of geometric designs and with a distinctive fringe. Fine strips of black, brown and un-dyed flax form the crisscross pattern of the kete whakairo (finely woven bag). The kete, made before 1833, is highly valued both for its age and for its very fine workmanship.

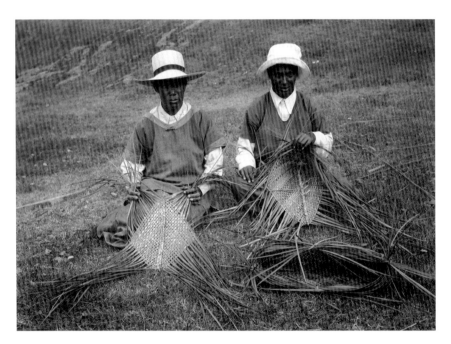

Te Paea Collier (left) and her sister Erana Heihi weaving kete, Waiapu region, East Cape, 1923.
Photograph by James McDonald

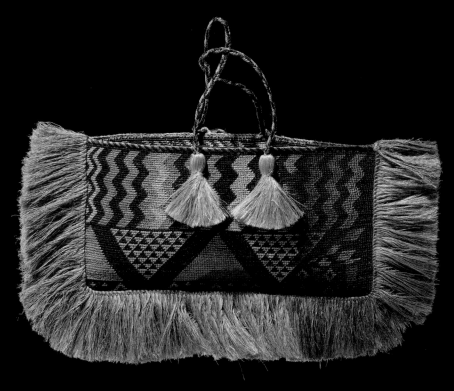

**Kete tāniko
(geometrically
patterned bag)**

Te Huringa I 1800–1900
Ngāti Porou
Flax fibre / 185 x 350 x 45 mm
Purchased c. 1900

**Kete whakairo
(finely woven bag)**

Te Huringa I 1800–1900
Iwi unknown
Flax fibre / 280 x 600 x 70 mm
Purchased 1977

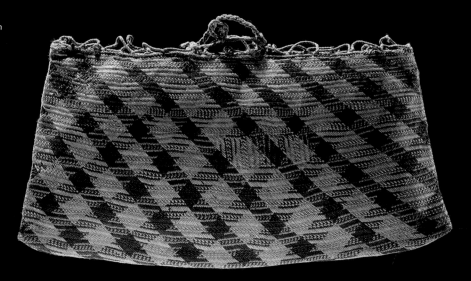

Muka (flax fibre)

Te Huringa I 1800–1900
Te Āti Awa
Flax fibre / 1100 x 50 mm
Gift of Ihaia Porutu, 1800s

Patu muka (flax fibre beater)

Te Huringa I 1800–1900
Tai Hauāuru (attributed)
Andesite / 218 x 77 x 77 mm

Securing the work

Turuturu whakamaua kia tina, tina!
Stand firm and carry on!

When a cloak is being woven, it is
stretched between two turuturu (weaving
pegs) anchored securely in the ground.
The word 'turuturu' means to make firm.
Turuturu hold the weaving upright and at
the correct height for the weaver, who sits
in front of the work. In former times, the
right hand peg of the pair was regarded as
sacred and the left was not.

Turuturu (weaving peg)

Te Puāwaitanga 1500–1800
Tai Hauāuru (attributed)
Tōtara wood / 490 x 45 x 56 mm
Purchased 1977

Carved fastenings

Aurei (cloak pins) were used to fasten customary Māori cloaks over the shoulder. Made from sea mammal bone, and later boar tusks, they were often embellished with fine carving and tied in bunches of several aurei clustered together.

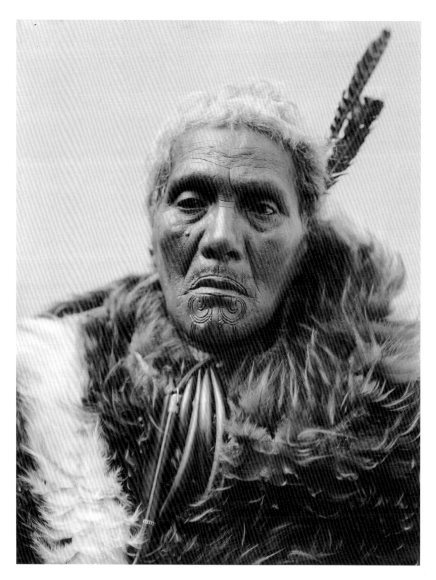

Hārata Te Kiore (Te Āti Haunui-ā-Pāpārangi), wearing cloak pins and a kiwi feather cloak, 1901–13.

Photograph by Augustus Hamilton

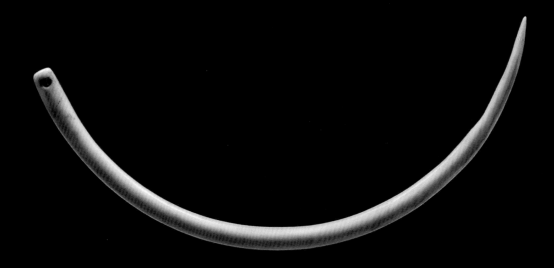

Aurei (cloak pin)

From top:

Te Puāwaitanga 1500–1800
or Te Huringa I 1800–1900
Iwi unknown
Bone / 123 x 60 x 6 mm

Te Puāwaitanga 1500–1800
or Te Huringa I 1800–1900
Te Āti Awa; from Taranaki region
Bone, pāua shell / 160 x 50 x 12 mm
Gift of A H Turnbull, 1913

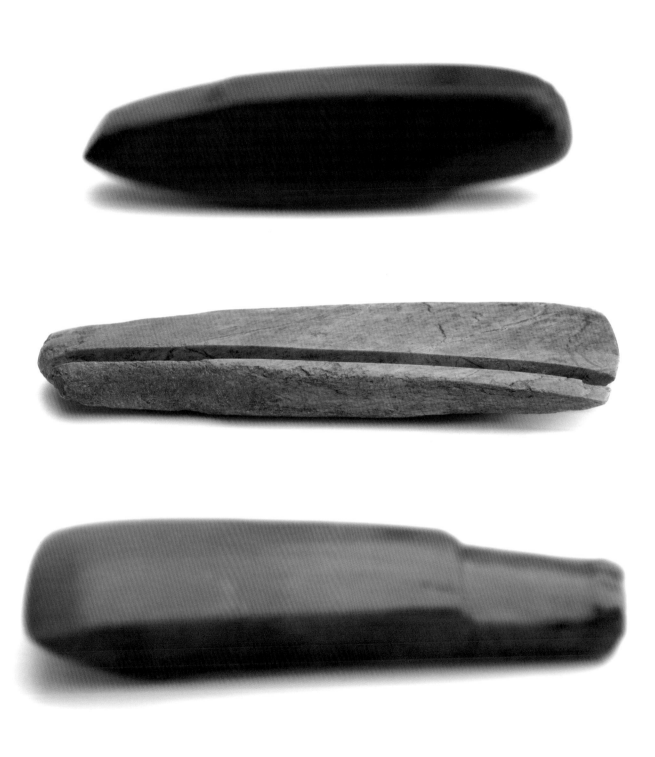

Glossary

haka vigorous dance with actions
hapū sub-tribe
harakeke New Zealand flax (*Phormium tenax*)
hei matau fish-hook pendant
hei tiki neck pendant in human form
heru ornamental comb
hīnaki eel trap
Hine Raukatauri deity of flutes
Hine-te-iwaiwa deity of weaving

iwi tribe; nation; people; bone

kaitaka fine flax cloak
kaitiaki guardian; custodian
kaitiakitanga guardianship, care for resources
kākā forest parrot (*Nestor meridionalis*)
kākahu woven garment; cloak
kapa haka Māori performing arts
karakia incantation; prayer
kererū wood pigeon (*Hemiphaga novaeseelandiae*)
kurī Pacific dog

mana prestige; power; authority; control
manaakitanga respect and care for one another
marae communal centre
marakihau sea creature
mauri life force; life principle
mere pounamu short-handled nephrite weapon
moko tattoo
muka processed flax fibre

pā strategic position; fortified village
papa hou treasure container
Papatūānuku the earth mother
pātaka storehouse
patu short-handled striking weapon
pekapeka bat / form of neck pendant
poi ball on cord
pou tokomanawa central support post
pounamu nephrite
poupou upright post
pūoro musical instrument

rangatira chief
Ranginui the sky father
Rongomātāne god of peace; god of kumara and
 cultivated food
tā moko the marking of skin; tattoo
taiaha long fighting staff
Tāne Mahuta god of the forest
Tangaroa god of the sea
tāniko geometric design
taonga treasure; something highly valued
taonga pūoro musical instrument
taonga tawhito treasure from early times
taonga whakarākai item of adornment
tapu sacred; prohibited; restricted
tauihu prow
taurapa sternpost
Tāwhirimātea god of winds
tawhito ancient
Te Ika-a-Māui The North Island
Te Moana-nui-a-Kiwa Pacific Ocean
Te Moana-tāpokopoko-a-Tāwhaki Tasman Sea
Te Wai Pounamu The South Island
tohunga priest; expert
tohunga whakairo master carver
toki adze
toki poutangata ceremonial adze
tukutuku woven or ornamental lattice work
Tūmatauenga god of war

waiata song
waka canoe; vessel
waka hourua double-hulled sailing vessels
waka huia treasure container
waka taua war canoe
whakairo carving
whakapapa genealogy; relationship
whānau extended family
whanaungatanga kinship
whao chisel
wharenui meeting house
whatu raranga woven objects

Pronunciation guide

The Māori language is phonetic – words are spelled as they sound. A macron (line over the vowel) indicates a long sound. When two vowels occur together, each retains its sound but the first merges into the second.

Vowel	Equivalent sound in English
a	as in far
e	as in met
i	as in me
o	as in awe
u	as in moon

Consonants	Equivalent sound in English
ng	as in sing
wh	like f (or w or h, depending on the tribal dialect)
r	close to l (not rolled)
p	softer than English p
t	softer than English t, close to d

Notes

1. Elizabeth Hura, 'Te Heuheu Tūkino II, Mananui ?– 1846' (*Dictionary of New Zealand Biography*, www.dnzb.govt.nz).

2. Edward Jerningham Wakefield, *Adventure in New Zealand, from 1839 to 1844: With Some Account of the Beginning of the British Colonization of the Islands* (London: John Murray, 1845) pp.109–10.

3. Hirini Melbourne, Richard Nunns and Aroha Yates-Smith, 'Te Hekenga-ā-rangi' (CD/DVD, 2003).

4. Erenora Puketapu-Hetet, *Maori Weaving: With Erenora Puketapu-Hetet* (Auckland: Pearson Education New Zealand, 1999) p.2.

All photographs are from the collections of the Museum of New Zealand Te Papa Tongarewa unless otherwise acknowledged. Illustrations on pages 99, 106 and 155 are from the sources below.

Sydney Parkinson, *A journal of a voyage to the South Seas, in his Majesty's ship, 'The Endeavour'* (London, 1784)

George French Angas, *The New Zealanders Illustrated* (London: Thomas McLean, 1847)

Index

Italics indicate pages with illustrations or information in captions.

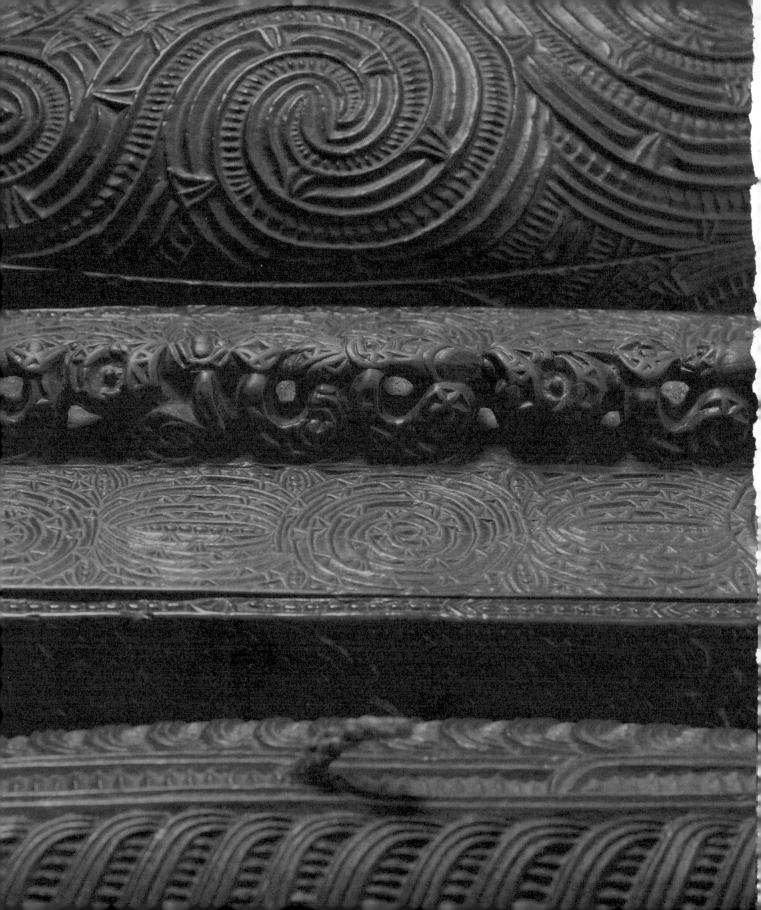